CHINESE BRUSH PAINTING

中國筆法畫

Step by Step

KWANY JUNG NA

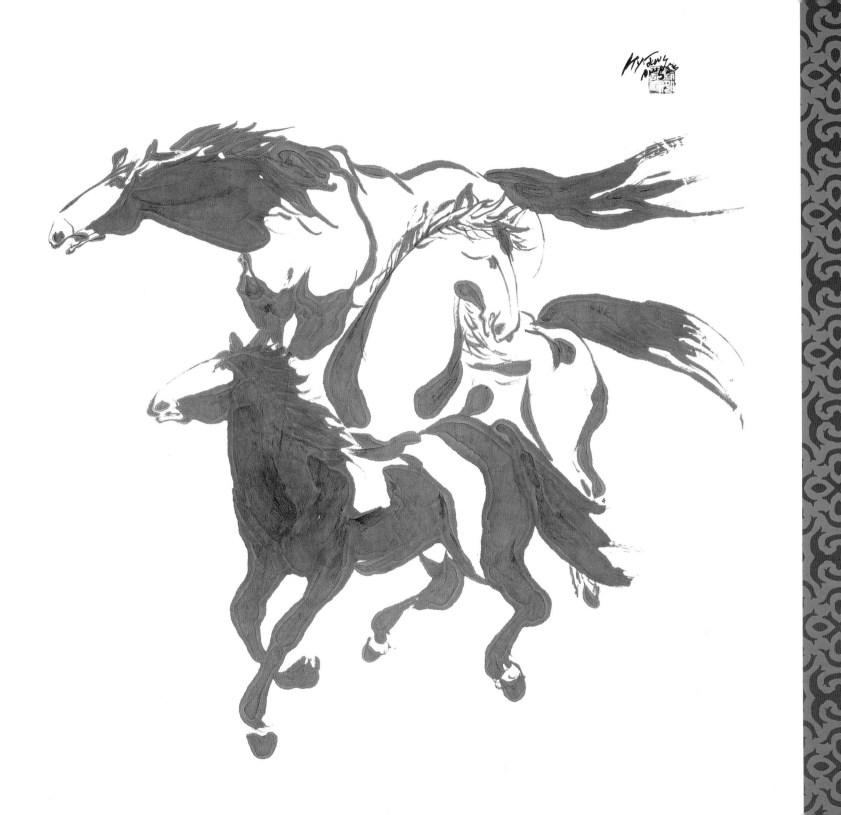

KWAN JUNG, NA

CHINESE BRUSH PAINTING
Step by Step

NORTH LIGHT BOOKS
CINCINNATI, OHIO
www.artistsnetwork.com

Chinese Brush Painting Step By Step. Copyright © 2003 by Kwan Jung. Manufactured in China. All rights reserved. No part of this book may be reproduced in any form or by any electronic or mechanical means, including information storage and retrieval systems without permission in writing from the publisher, except by a reviewer who may quote brief passages in a review. Published by North Light Books, an imprint of F&W Publications, Inc., 4700 East Galbraith Road, Cincinnati, Ohio, 45236. 1-800-289-0963. First Edition.

07 06 05 04 5 4 3

Library of Congress Cataloging in Publication Data
Jung, Kwan, 1932-
 Chinese brush painting step by step / Kwan Jung.—
1st ed.
 p. cm
 Includes index.
 ISBN 1-58180-207-2 (hc. : alk. paper)
 1. Ink painting, Chinese—Technique. 2. Watercolor painting, Chinese—Technique. I. Title.

ND2068 .J86 2003
751.4'251—dc21

 2002071858

Edited by James A. Markle
Designed by Lisa Buchanan
Production art by Julie Pennington
Production coordinated by Mark Griffin

THREE HORSES
Ink
27" x 27" (69cm x 69cm)
Art from page 2

METRIC CONVERSION CHART

TO CONVERT	TO	MULTIPLY BY
Inches	Centimeters	2.54
Centimeters	Inches	0.4
Feet	Centimeters	30.5
Centimeters	Feet	0.03
Yards	Meters	0.9
Meters	Yards	1.1
Sq. Inches	Sq. Centimeters	6.45
Sq. Centimeters	Sq. Inches	0.16
Sq. Feet	Sq. Meters	0.09
Sq. Meters	Sq. Feet	10.8
Sq. Yards	Sq. Meters	0.8
Sq. Meters	Sq. Yards	1.2
Pounds	Kilograms	0.45
Kilograms	Pounds	2.2
Ounces	Grams	28.4
Grams	Ounces	0.04

ABOUT THE AUTHOR

Kwan Jung, NA, was born to a Chinese-American family whose home has been San Diego, California, for many generations. In 1962 he married Yee Wah, who is also an award-winning artist. For many years they worked in a family-owned restaurant, which gave them the freedom during the day to hone their artistic skills and raise their three daughters, Jeanne, Kathy and Laura. In 1988 they retired from the restaurant business to devote their time to painting.

Kwan studied painting while attending college in Hong Kong, concentrating on both Western art and traditional Chinese painting. He works in many different mediums, including watercolor, oil and acrylic. His artwork covers a wide range of subjects from Chinese brushwork to traditional portraiture. He is perhaps best known for his landscape paintings, which have been seen in exhibitions and publications nationwide.

Kwan is an award-winning member of the National Academy of Design, the American Watercolor Society and the National Watercolor Society. His work can be found in many collections and various exhibits throughout the United States.

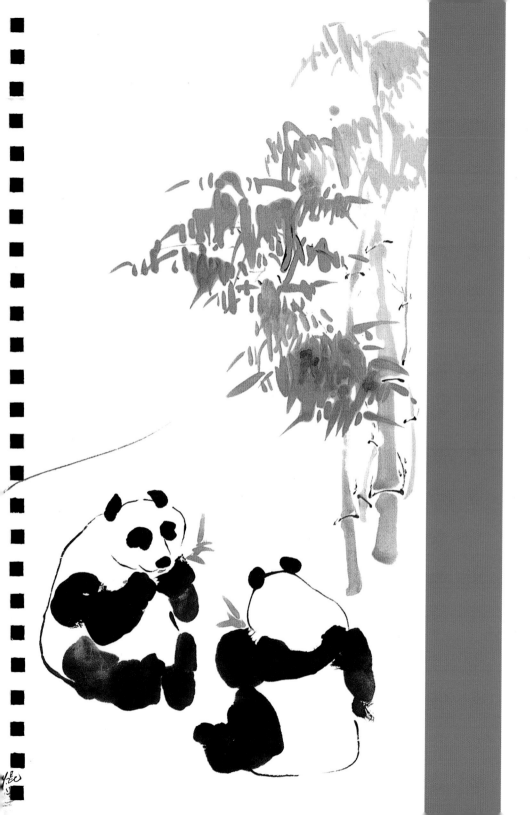

ACKNOWLEDGMENTS

I wish to thank F&W Publications, Inc., North Light Books, acquisitions editor Rachel Wolf, editor Jamie Markle and their staff for the publication of this book. Without their helping hands, my book would have remained just an unsuccessful idea.

Next, I want to thank all of my artist friends in the Circle Ten, especially Mrs. Eileen Monaghan Whitaker, Ms. Jan Jennings, Dr. Roy Paul Madsen and his wife Barbara, Comdr. Stanislaus J. Sowinski and his wife Jackie. I appreciate all the support, enthusiasm, encouragement and advice you have given to me in life, in art and also in helping me to write.

Last but not least, a special thanks to my family, especially to my wife Yee Wah and our daughter Laura for keeping their watchful eyes on me when I was working day and night trying to get to the final version of this book.

DEDICATION

This book is dedicated to San Diego, my ideal hometown.

BAMBOO AND PANDA
Acrylic and ink
59" x 32" (148cm x 80cm)

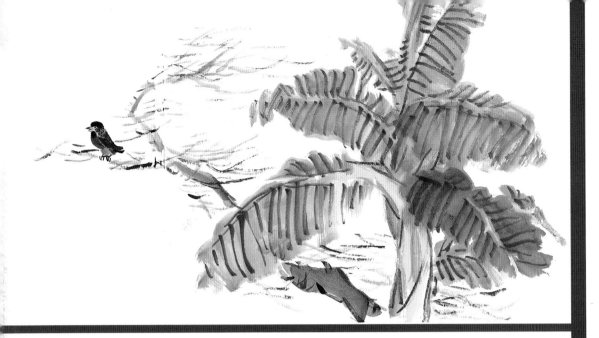

TABLE of CONTENTS

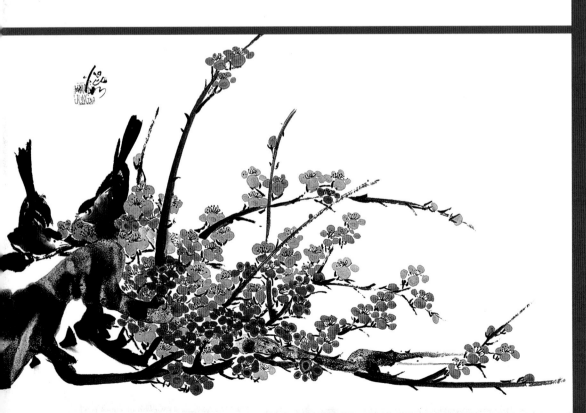

1 INTRODUCTION TO BRUSHWORK

page 11

Before you can master Chinese brush painting, you must learn the basic fundamental concepts, principles and elements required to construct any work of art. After learning how correct composition creates the structure and mood of your painting, you will learn about the proper materials and tools needed to help you get the job done. A simple demonstration shows you all the strokes you need to be able to express your ideas through Chinese brush painting.

2 CREATING BRUSH PAINTINGS, STEP BY STEP

page 29

Twelve lessons will help you develop a strong foundation in Chinese brush painting techniques, enabling you to paint your subject matter using a bamboo brush. You will learn how to paint different plants and flowers, including bamboo, grape leaves, hibiscus, mums and peonies. You will also learn how to paint animals such as the panda, mandarin duck, goldfish and horse. Once you are familiar with these twelve lessons, you will have no difficulty creating your own Chinese brush paintings.

A SIMPLE CRITIQUE

BY COMPARISON

Once a work of art is complete, we can view it, *feel* it and make a judgment. By determining the characteristics of a painting, you can learn how to capture the mood and effect you want to create in new paintings.

GALLERY

A collection of the artist's work shows what can be done with Chinese brush painting.

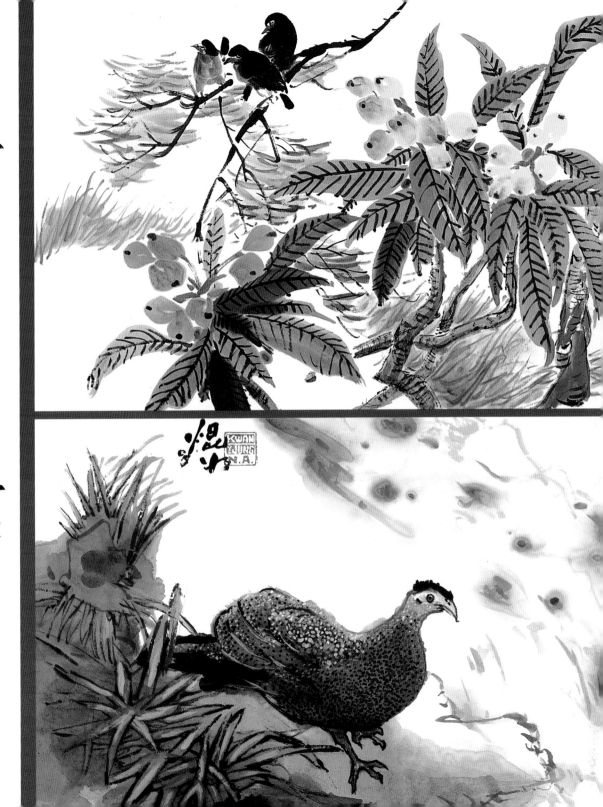

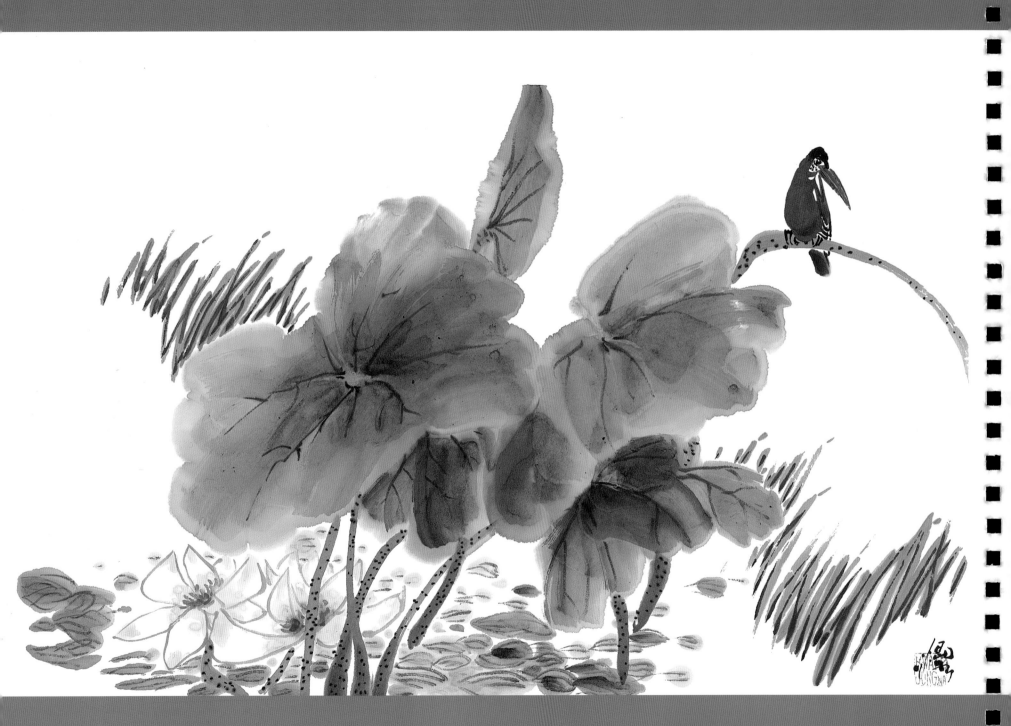

INTRODUCTION

Shitao (1641-1707) was the best Chinese brush painter of the Qing Dynasty (1644-1911). His style has dominated the painting world in China for the last four hundred years. A Buddhist monk who also loved nature, he coined many of the more than twenty-two aliases by which he was known. His contemporaries have faithfully followed this trend, and many artists still follow the practice.

Contemporary Chinese brush painters use many aliases, including Mountaineer, Firewood Gatherer, Cloud, Pine, Stream, Villager, Rice Field, Buffalo, Buddha Monk, Taoist, Hermit and Stone Master. Most of the names are closely related to nature.

Living near nature is the goal of these painters' minds. It is within nature that they seek the meaning of life; coexisting with other creatures and plants is their goal. These artists answer the call from heaven to work harmoniously with other human beings to improve our life on Earth. The poems and inscriptions in their Chinese brush paintings glorify the beauty of all living things. These painters rarely consider the monetary value or commercial success of their art.

FISHER AND LOTUS FLOWER
Acrylic
17" x 26" (43cm x 66cm)

The opaque watercolor painting of the Northern School of Chinese painting dominates the commercial world. Northern School watercolors are full of color and detail, with designs crafted to the needs and desires of the patron. The transparent watercolor of the Southern School of Chinese painting belongs to the minds of the intellectuals. The Southern School remains the amusement of the painter. It is an avocation that allows painters to express themselves and make peace with the world. Most Chinese painters favor the scholarly style of the Southern School.

Through art, we can connect to the universe. To avoid stress, anxiety, insecurity and uncertainty in life, we need to change paths from time to time. In the United States, many seek haven in the countryside, escape to snowy mountains, vacation by the seashore or retreat to the wilderness for a week. We escape from the daily chaos of our lives by practicing yoga, meditating, developing hobbies and playing sports. These things give our busy minds a break and improve our health. Chinese brush painting can do the same. The subject matter of Chinese brush painting focuses on the beauty of nature, causing us to stop and take notice of the flowers and birds, animals and insects, plants and rocks, the Earth and our connection to it.

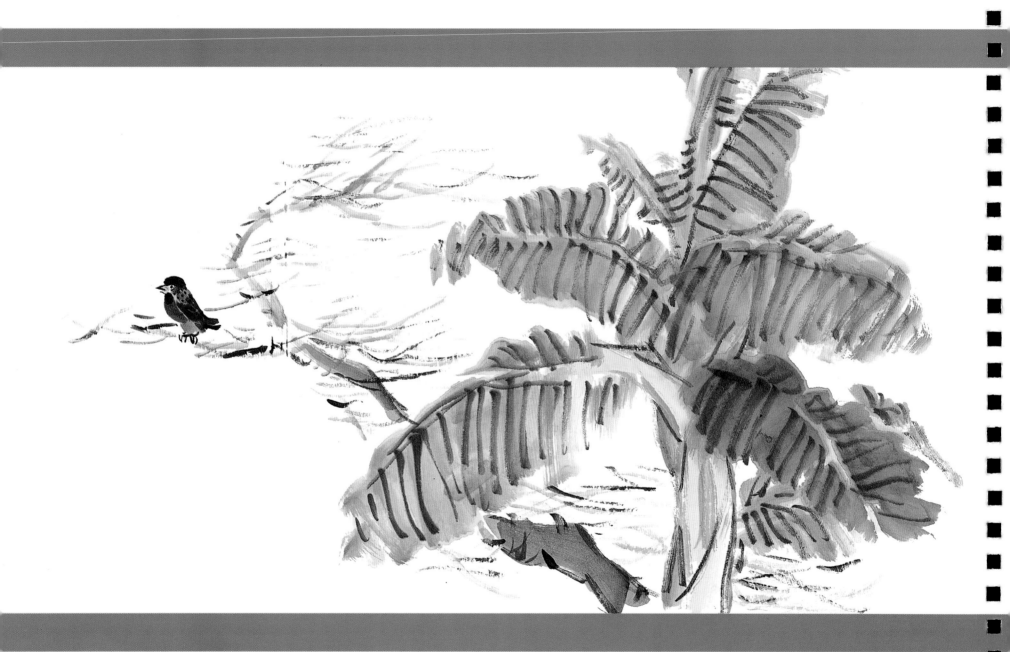

INTRODUCTION
TO BRUSHWORK

With a few strokes a painting is done; in just a few minutes you have created a work of art. Your bamboo brush dances here and there on paper, creating an image from your mind. Your hand performs magically, doing as you wish, as if you possessed a magic wand. No matter what subject you want to paint, it is done in a jiffy. That is Chinese brush painting. The Chinese describe this type of action as, *Yet Fei Er Jeou*—everything done successfully, in place, with one stroke. This type of action can be done. It is a fact demonstrated through experiences.

Chinese brush painting is similar to other types of performing arts. We can refine our methods perfectly through training, practicing, reciting, rehearsing and jamming before the debut performance. The art of Chinese brush painting must follow all of these processes. There are requirements, guidelines and strategies to follow to ensure that every stroke made will result in an elegant, successful painting. This section is devoted to preparing you for success and to introduce you to the tools you need so that you are ready to begin brush painting.

SPARROW AND BANANA TREE
Acrylic
13" x 24" (33cm x 61cm)

Brush painting originated in China. This art form is derived from Chinese calligraphy, therefore it is done in the same manner as handwriting or creating a piece of calligraphy. From start to finish, it only takes a few minutes, not hours as other paintings require. It is the most direct kind of painting in the world. This spontaneous, positive approach involves the application of clean-cut brushstrokes applied directly to the paper without previous planning or pencil sketching.

Brush painting has many other names. It is sometimes called water and ink painting, Southern School painting, sumi-E painting, four gentlemen painting and flower and bird painting. No matter what name people call it, brush painting consists of three parts: (1) the subject matter of the painting, (2) the signature of the artist or the calligraphy and (3) the seals of the artist.

The calligraphy can be an inscription, a verse or any poetry handwritten by the artist. Although all three elements are related, this book is mainly concerned with the subject matter of the painting.

THE PAINTING SEQUENCE
First, paint the flower as the subject. Then write the inscription or signature and finally place the seal.

HIBISCUS FLOWER
Watercolor
8" x 18" (20cm x 46cm)

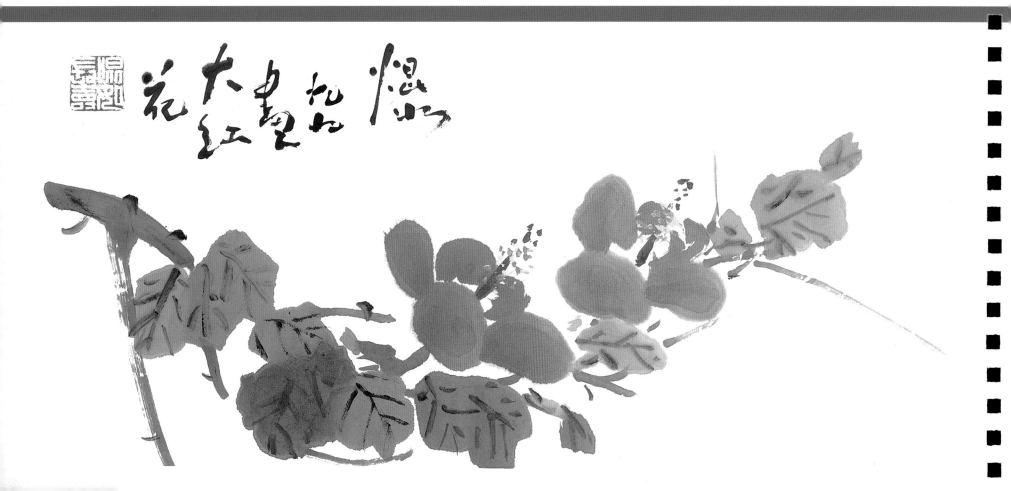

VIEWPOINT

The viewpoint most frequently used in brush painting is the bird's-eye view. In virtually every instance, whether the subject is a broad land-scape or an intimate subject (birds, flowers or figures), the bird's-eye view offers the greatest possibilities for design. Consequently, many things can be shown in a small area. This differs from the traditional Western approach of selecting an eye-level viewpoint when interpret-ing the subject.

PAINTING ROOSTERS AND HENS

Working upward from the ground of the paper, paint the rooster from the head down to the feet. Add the hen next to the rooster, painting from the beak to the tail. Finally, add the grass and bamboo.

ROOSTER AND HEN
Watercolor
24" x 11" (61cm x 28cm)

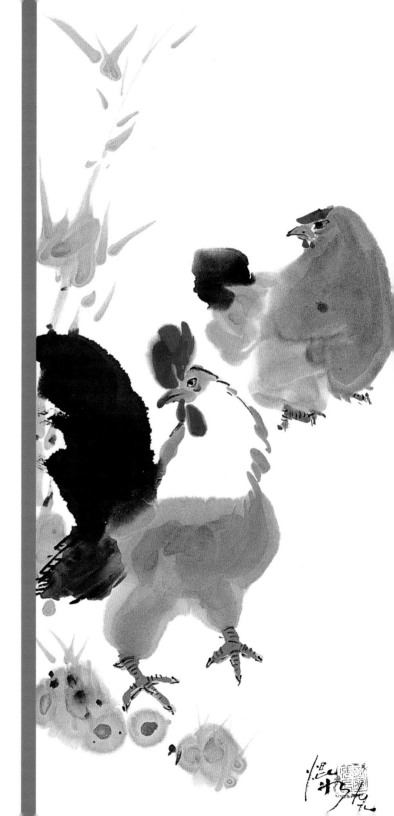

Many contemporary paintings have compositions with multiple subjects combined in one setting. These very crowded compositions resemble the shelves of a grocery store. With so many elements, all of the subjects have equal importance in the painting. The compositions used in brush painting are concerned with the center of interest and the dispersion of visual elements across the surface of the painting.

Dispersion allows for space between each element and avoids the overlapping of subjects. This relieves tension within the painting by eliminating overcrowded spaces. The viewer's eye is free to move from space to space within the painting without having to examine every detail of an illustrative approach.

The simplicity provides a sense of relief to the viewer—only what is artistically pleasing is included and all else is eliminated. What is unseen is then experienced by the imagination.

Concentration and dispersion govern composition in brush painting. On the one hand, there is a grouping of visual elements intended to be the center of interest. On the other, there is a dispersion and aesthetic balancing of breakaway artistic elements which include the artist's signature and inscriptions. To the viewing eyes, it is an easy trip and a pleasant journey. To the artist's mind, it is a simple rule to follow. Consequently, the artist can afford to pay more attention to the performance of the brush and can produce better brushwork.

CONCENTRATION AND DISPERSION

The rose and the bluebird are the center of interest in this painting. An attractive bright red and blue color are used for the rose and the bird in the center of the painting. The grapes and vines are painted with lighter values of color; they are the dispersion elements in the painting. First the rose is painted, then the vines and the grapes. Next the bluebird is added and the subject matter is balanced with the signature of the artist and the seal.

ROSE, BLUEBIRD AND GRAPE
Watercolor
13" x 25" (33cm x 64cm)

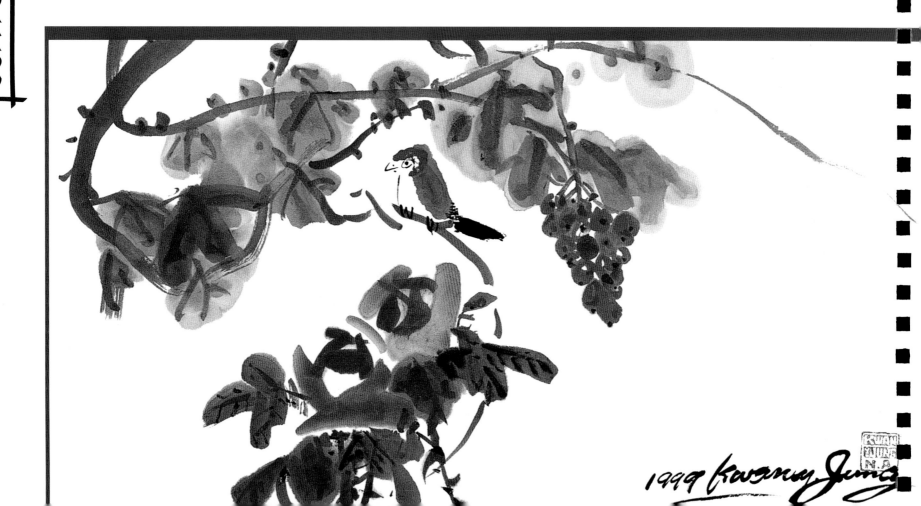

1999 Kwang Jung

BALANCE

When the center of interest and dispersed visual elements have been painted, the signature and seal are used to create the final aesthetic balance of the painting. The subject matter is balanced by the signature and seal.

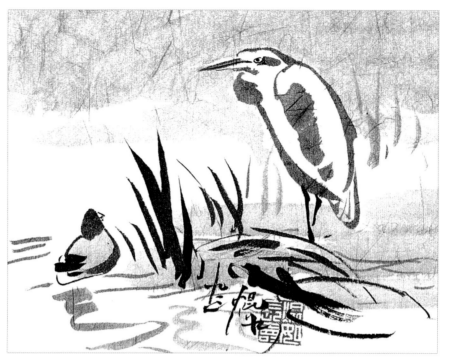

CONCENTRATION

When a painting is finished, a directional flow can be found within the painting. This flow runs from the center of interest to the dispersed elements, forming a curved line or circle. Place the signature and the seal within this directional flow. One way to place them is at the beginning of the flow, becoming a part of the center of interest; this is known as concentration. When there are enough elements around the center of interest, it is a join-in seal and signature.

WATERFOWL WITH JOIN-IN SIGNATURE AND SEAL
Ink
8" x 10" (20cm x 25cm)

DISPERSION

The second way to place the signature and the seal is at the end of the flow or far away from the center of interest. They become part of the secondary elements; this is known as dispersion. When there are not enough elements to confirm a balance in the painting, dispersion acts as the balancing leverage. This is known as a breakaway signature and seal. Remember, it is kept within the directional flow in the painting.

BOK CHOY WITH BREAKAWAY SIGNATURE AND SEAL
Ink
8" x 10" (20cm x 25cm)

PERSPECTIVE

A sense of distance is implied through the variation of the tones of the ink or color. Gradating values set objects farther back or nearer, as seen in traditional outdoor perspective. An object is darker when it is closer to the viewer. Objects appear to be lighter when they are farther away from the viewer. Chiaroscuro—the use of light and shadow to create form—is seldom used. Consequently, there is no need to paint shadows in most brush paintings.

VARY VALUE TO CREATE PERSPECTIVE

Apply the strongest color and ink when painting the chrysanthemum. Decrease the color value in the brush to paint the rock. Use the lightest value of color to paint the bamboo.

CHRYSANTHEMUM, ROCK AND BAMBOO
Watercolor
25" x 17" (64cm x 43cm)

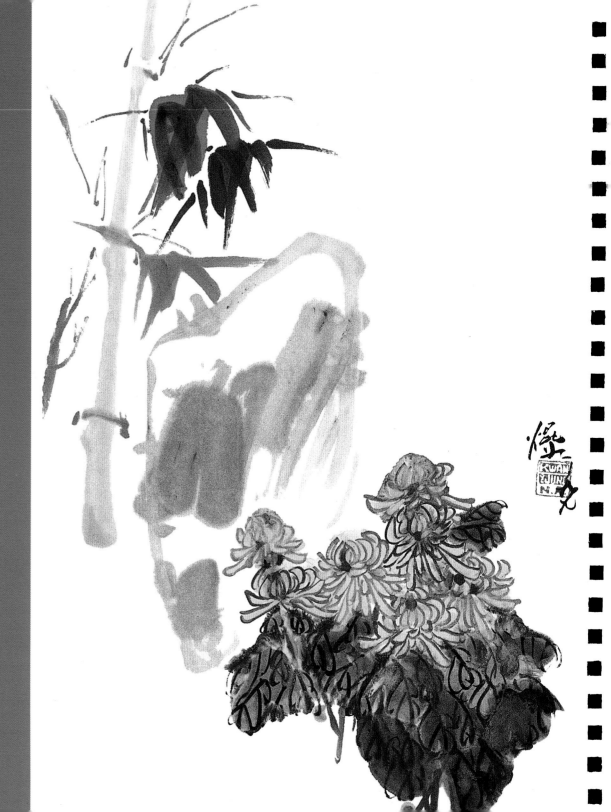

BRUSH

Most of the brushes available for brush painting contain some type of hair selected from animals, such as wolves, horses, sheep, goats and squirrels. Some brushes are made of synthetic materials, but they tend to be mushy in their handling even if reinforced with some animal hair.

I prefer to use a pure white sheep hair round brush, 1½ inches (38mm) long by ⅓ inch (9mm) wide, which narrows to a fine point. A sheep hair brush holds more water than a sable hair brush and enables me to render bolder and more expressive brushstrokes without running dry. I use it largely for bold and swift strokes, broad washes and large character writing. The sheep hair brush maintains its shape well, lending itself to fluent twists and turns without spreading the hairs.

Sable hair brushes lack the versatility of sheep hair. Sable hair brushes are used effectively in painting a bamboo tree because the strokes are usually in one general direction. They are resilient and have a fine point, which is good for detailed work. They hold their fine point well and are useful for fine character writing and landscape paintings. All of this requires changing brushes constantly to make the form follow the function.

I would be in trouble if I were to change brushes while painting. I am able to achieve all the effects I want with a single sheep hair brush. The sheep hair brush expresses virtually everything I have to say visually. It is an extension of my artistic self, and I scarcely need to think about the brush when rendering my subjects in the most spontaneous way. Through this brush, the painting flows from the inner me to the outer paper without the distraction of making alternative selections.

THE WHITE SHEEP HAIR BRUSH

White sheep hair brushes ranging from 1½ inches (38cm) to 2 inches (51cm) long. They are the most important tools in brush painting.

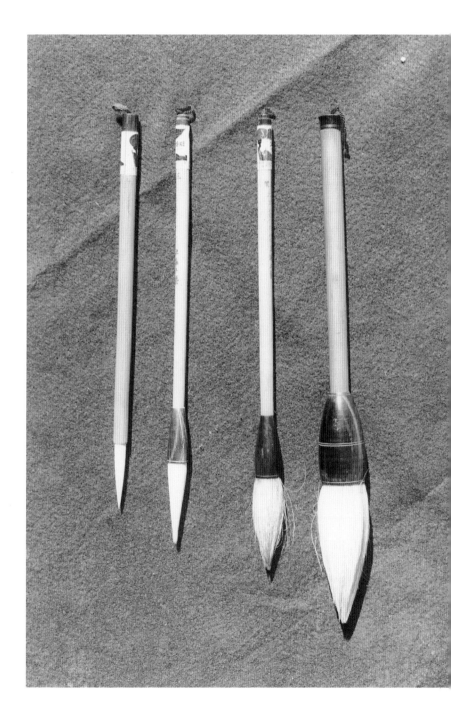

HOW TO HOLD THE BRUSH

There are two basic ways to hold the brush. The grips for brush painting are the same as the grips for writing Chinese characters. The first is the vertical lock-in hold. You use four fingers to hold the brush—the thumb, the index finger, the middle finger and the ring finger. In illustration no. 1, the thumb presses the brush against the inside of the index and the middle finger with the back of the ring finger pressed against the brush at the bottom. The brush is locked in by the index finger, the middle finger on one side and the thumb, with the ring finger on the other side. To paint or write, the wrist of this vertical lock-in hold hand is placed firmly on the top of the table. This grip is used to draw small, fine and even strokes.

The second brush hold is the three-fingers hold as shown in illustration no. 2. Place the brush between the index finger and the middle finger. Then apply pressure to the brush from the thumb by pressing hard against both the index and the middle finger. This grip is used when painting large, undetailed images.

Your grip will vary according to the work being painted. For painting while sitting in a chair or for drawing small details, hold the brush near the bristles using the lock-in hold. For painting while standing up or drawing subjects that are long and big, hold the brush end farthest from the bristles using the three-fingers hold. The three-fingers hold is most frequently used in this book.

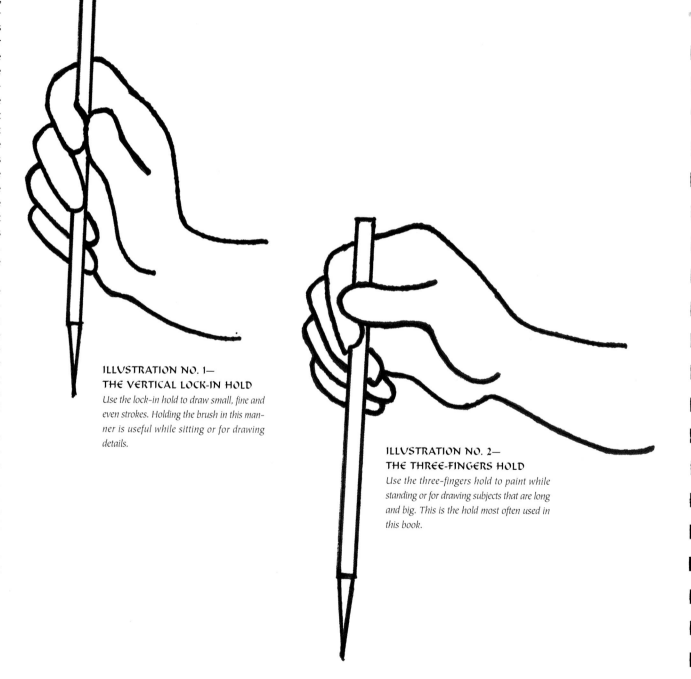

**ILLUSTRATION NO. 1—
THE VERTICAL LOCK-IN HOLD**

Use the lock-in hold to draw small, fine and even strokes. Holding the brush in this manner is useful while sitting or for drawing details.

**ILLUSTRATION NO. 2—
THE THREE-FINGERS HOLD**

Use the three-fingers hold to paint while standing or for drawing subjects that are long and big. This is the hold most often used in this book.

THE INK

The inks used in brush painting go back a thousand years to the Shang dynasty in China, when they were used to paint characters on cloth and bamboo. The inks traditionally come in the form of dry sticks, which are ground up in a pestle (ink stone). Water is added to achieve the desired consistency. Grinding ink sticks is tricky and often requires half an hour of careful preparation before painting can begin. Today, ink comes bottled in liquid form for convenient use. Unfortunately, I have found that the liquid form is never quite the consistency I prefer. My solution has been to pour some ink out of the bottle onto the pestle, and then grind in as much of the stick ink as is necessary to obtain the consistency I desire. This procedure of combining liquid ink with dry ink sticks greatly shortens the preparation time. Another method is to dilute black acrylic paint from a tube with enough liquid ink and mix them to the desired consistency.

VARIOUS INK TYPES
Ink sticks, a stone used to grind ink sticks on and bottled ink.

Rice paper is the best kind of paper to use for brush painting. It is lightweight, translucent, absorbent and will faithfully record all of the rendered brushstrokes. This paper has the unique power to absorb water from the brush and prevent it from running down the surface of the paper. However, rice paper is thin, which precludes over-absorption and permits a sensitive, quick response to every brushstroke. The artist must remain in control of the brushwork and the amount of water retained in the brush. There is a tendency for the images to lose sharp edges through the absorption process while painting. The paper does the blending and shading of the brushwork through its natural ability to absorb water. This softness may be avoided by using less water; you may even use a nearly dry brush.

There are many kinds of usable rice papers on the market. Some papers labeled as rice paper are not actually made from rice. They are made of such materials as cotton, flax, beans, grass and bark from hibiscus bushes; these lack even the most tenuous connection with genuine rice paper. Years ago, one could buy rice paper at the local Chinese grocery store and either eat it or make candy with it. Today, you can purchase rice paper at your local art store, but be sure to purchase genuine rice paper for your brush painting. You should insist upon imports from China or Japan.

The most common and desirable form of rice paper is Xian paper, sometimes called Tofu Xian. This has the right combination of the desirable qualities of thinness, absorbency and responsiveness to the brush. Other brands of rice paper will vary to some degree in texture and painterly qualities and, ultimately, the brand used will be the personal preference of the artist. I find that the two-ply Xian paper works best.

Different papers can create different shapes. For example, there are different results when composing a painting on Xian paper and linen paper. The subject matter and the brushwork are similar but the result is not. Xian paper has the ability to absorb the water, resulting in a smooth and soft look. Paintings on linen paper appear to be flat and hard-edged because linen paper cannot prevent the spreading of the watercolor.

RICE PAPER

Paper made from rice has the desired qualities of strength, weight, absorbancy and transparency.

DOVE PAINTING ON XIAN PAPER
Ink
11" x 9" (28cm x 23cm)

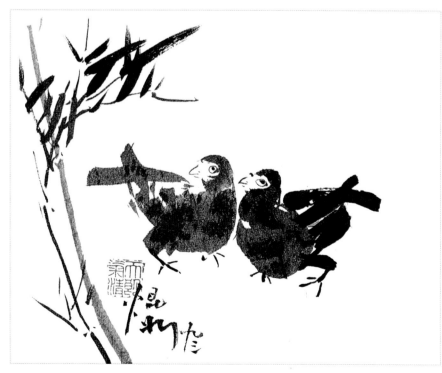

LINEN PAPER

Linen paper does not absorb like rice paper; therefore, the watercolor spreads and forms a hard edge.

DOVE PAINTING ON LINEN PAPER
Ink
9" x 12" (23cm x 30cm)

OTHER MATERIALS NEEDED FOR BRUSH PAINTING

Beside brushes, ink and paper, there are a few other supplies required for brush painting:

— Paper towels are needed to wipe off or absorb the excess water or color from the brush.

— Water wells or water containers are used for frequent cleaning of the brush.

— Dishes are required for mixing and storing colors.

— Watercolor is best for painting flowers. Transparent watercolor is better than opaque watercolor for brush painting.

— Acrylic paint is also a very good alternative medium for brush painting.

— Two yards of thick wool cloth is used to place under the paper while painting. This protects the table from ink spills and water stains.

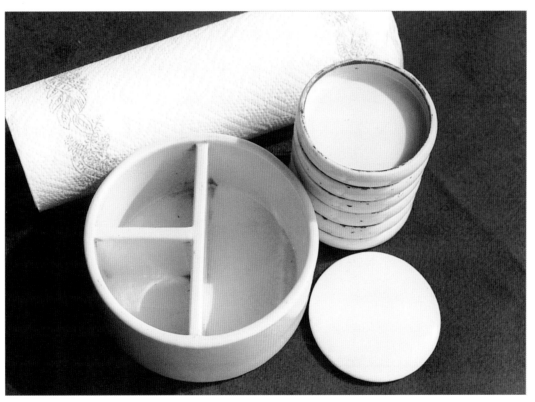

OTHER NECESSARY SUPPLIES
Water wells, dishes, paper towels and a wool cloth are some of the other supplies you will need to complete the demonstrations in this book.

ACRYLIC PAINTS

Watercolor paints are more beautiful than acrylic paints, but are also more expensive. With acrylic paint I can make washes, repaint and cover it many times and my paintings still look transparent. When I work on rice paper with watercolor, my paintings have a beautiful powdery appearance. When I need more flexibility in my painting, I use acrylic. Acrylics are convenient and easy to use, but I could use watercolor if I wished. My palette is simple: Bright Orange, Burnt Umber, Cadmium Orange, Cobalt Blue, Deep Violet, Hooker's Green, Lemon Yellow, Naphthal Crimson, Raw Umber, Sap Green, Turquoise, Ultramarine Blue and Yellow Ochre.

The act of brushwork deserves some discussion. Most often, the forms and patterns of the subject dictate the nature of the brushwork used to render it. However, frequently the strokes made must be an interpretation rather than a rendition.

Only experimentation and experience can teach an artist how much ink and water to pick up with the brush to describe each form. Only practice in rendering the form of each subject will give an artist the skill to interpret them with quick, articulate strokes. I have frequently painted prawns as subjects and have developed a visual vocabulary for describing them. There are ten different kinds of brushstrokes used to render this prawn, requiring that the brush be manipulated in ten different ways. Each demands the right amount of ink and water in both wet and dry strokes.

CREATE INTEREST IN SIMPLE SUBJECTS

To make the painting more interesting, various values are employed in each prawn.

THE PRAWN
Ink
9" x 13" (23cm x 33cm)

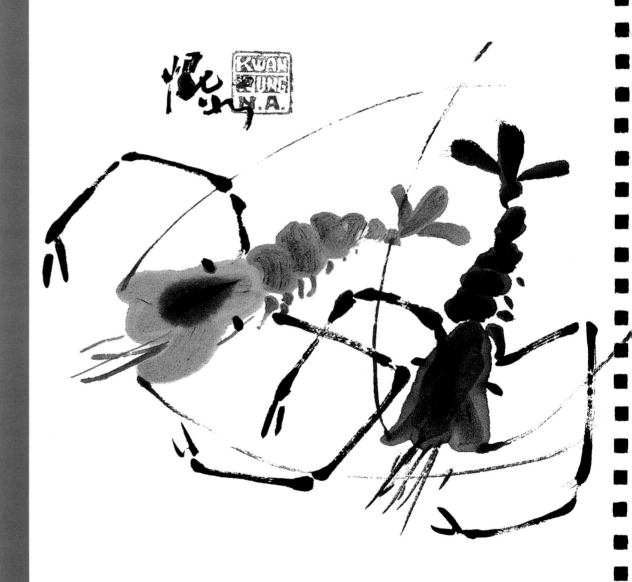

EXAMPLES OF BRUSHWORK

A prawn painting is made of ten different strokes used to make many shapes: (1) head, (2) body, (3) tail, (4) short whiskers, (5) feet, (6) claws, (7) arms, (8) long whiskers, (9) brain, and (10) eyes. There are at least three tones of ink applied to the painting, ranging from light value to middle value to dark value. The light value is for the head of the prawn; the body is painted with a middle value, and the brain and eye are applied with a heavy, dark value. Practicing the prawn painting is a marvelous tool for improving your brushwork.

PRACTICE STROKES

These ten different strokes are all you need to begin painting. Learning these strokes will give you the basic strokes used in brush painting.

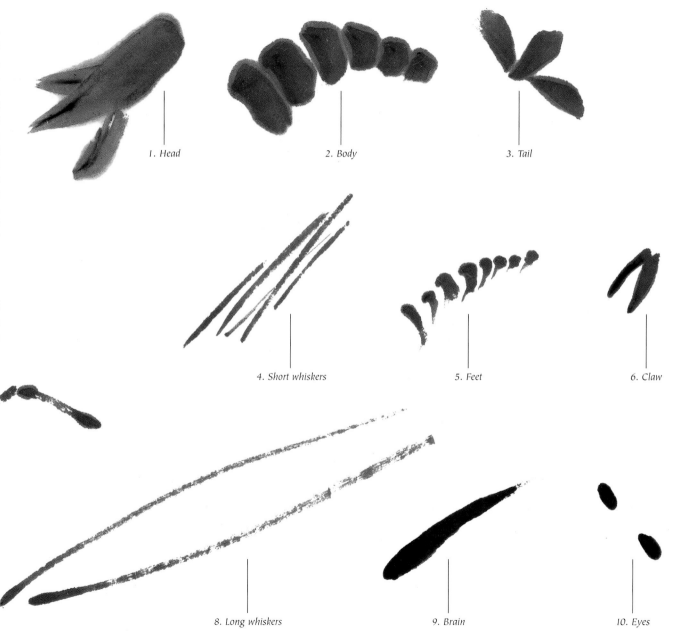

1. Head

2. Body

3. Tail

4. Short whiskers

5. Feet

6. Claw

7. Arm

8. Long whiskers

9. Brain

10. Eyes

CREATING THE BASIC BRUSHSTROKES

Follow these step-by-step instructions to master the strokes you need to begin brush painting.

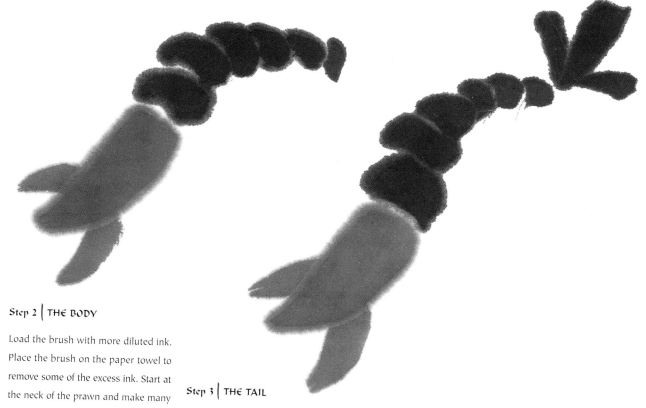

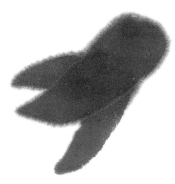

Step 1 | THE HEAD

Soak the brush with light ink. Make three blunt strokes with a slanting brush. Paint the center stroke by pressing the brush all the way down to the paper without moving the tip of the brush. The center stroke will be the longest of the three. Paint two blunt, shorter strokes halfway down the first stroke, one on each side of the center one. All three strokes should be soggy and wet.

Step 2 | THE BODY

Load the brush with more diluted ink. Place the brush on the paper towel to remove some of the excess ink. Start at the neck of the prawn and make many half-moon-shaped strokes, one parallel to the other. They should become progressively smaller as they approach the tail.

Step 3 | THE TAIL

Three smaller strokes are needed to form the tail. With the same brush, connect the last body shell of the prawn to the tail by making three strokes, each one facing a different direction. Paint the center one first, followed by the other two. Make sure the end of each stroke is a little bit wider than its beginning by pressing the brush before lifting up.

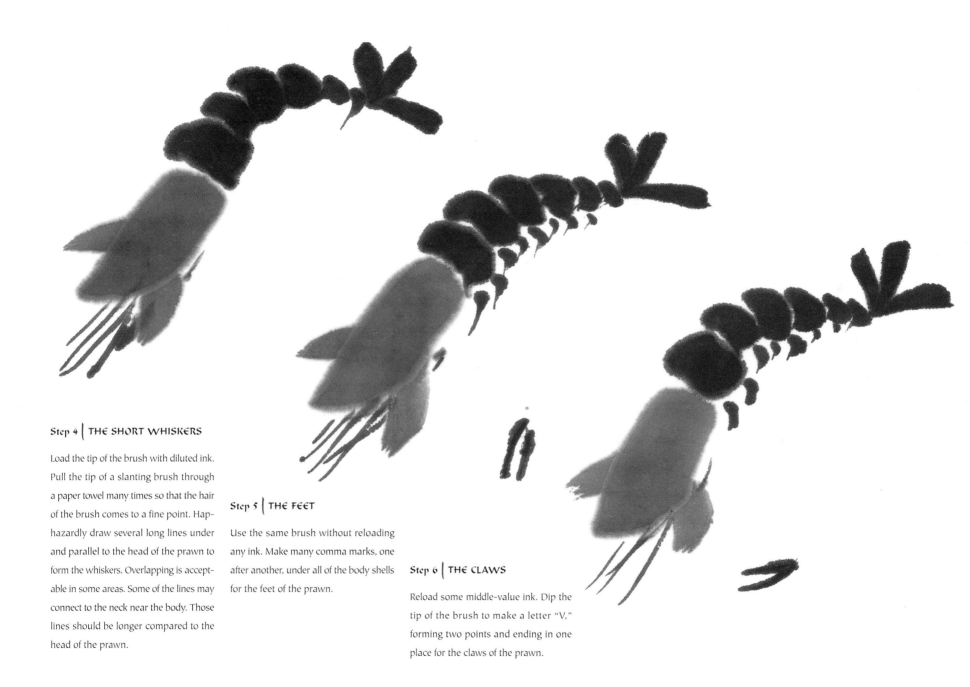

Step 4 | THE SHORT WHISKERS

Load the tip of the brush with diluted ink. Pull the tip of a slanting brush through a paper towel many times so that the hair of the brush comes to a fine point. Haphazardly draw several long lines under and parallel to the head of the prawn to form the whiskers. Overlapping is acceptable in some areas. Some of the lines may connect to the neck near the body. Those lines should be longer compared to the head of the prawn.

Step 5 | THE FEET

Use the same brush without reloading any ink. Make many comma marks, one after another, under all of the body shells for the feet of the prawn.

Step 6 | THE CLAWS

Reload some middle-value ink. Dip the tip of the brush to make a letter "V," forming two points and ending in one place for the claws of the prawn.

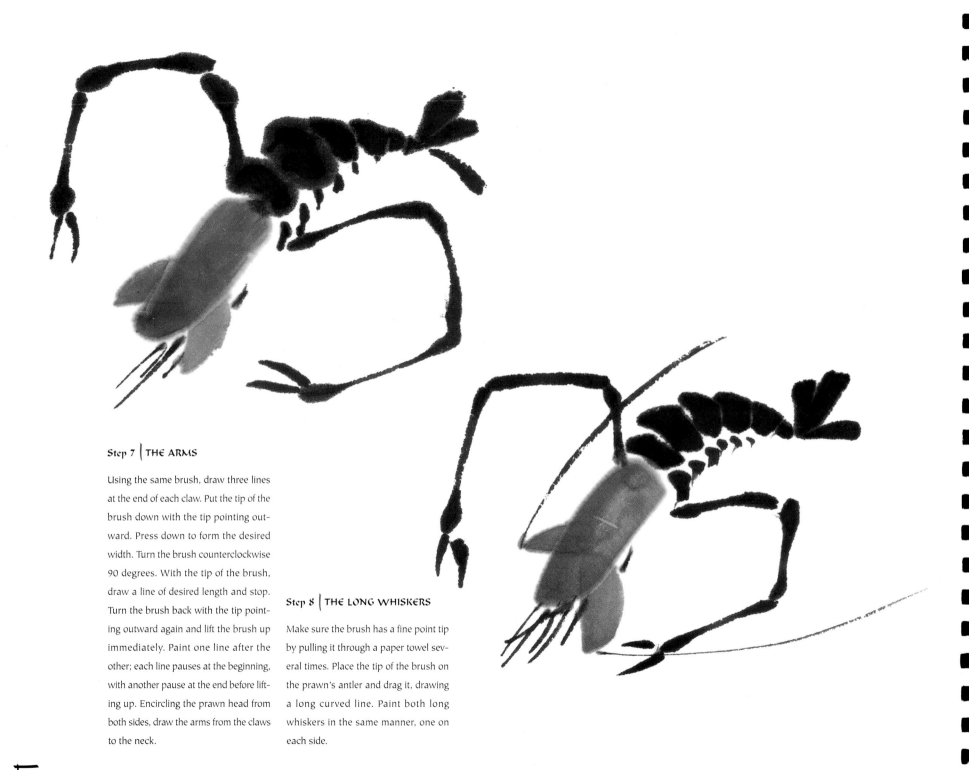

Step 7 | THE ARMS

Using the same brush, draw three lines at the end of each claw. Put the tip of the brush down with the tip pointing outward. Press down to form the desired width. Turn the brush counterclockwise 90 degrees. With the tip of the brush, draw a line of desired length and stop. Turn the brush back with the tip pointing outward again and lift the brush up immediately. Paint one line after the other; each line pauses at the beginning, with another pause at the end before lifting up. Encircling the prawn head from both sides, draw the arms from the claws to the neck.

Step 8 | THE LONG WHISKERS

Make sure the brush has a fine point tip by pulling it through a paper towel several times. Place the tip of the brush on the prawn's antler and drag it, drawing a long curved line. Paint both long whiskers in the same manner, one on each side.

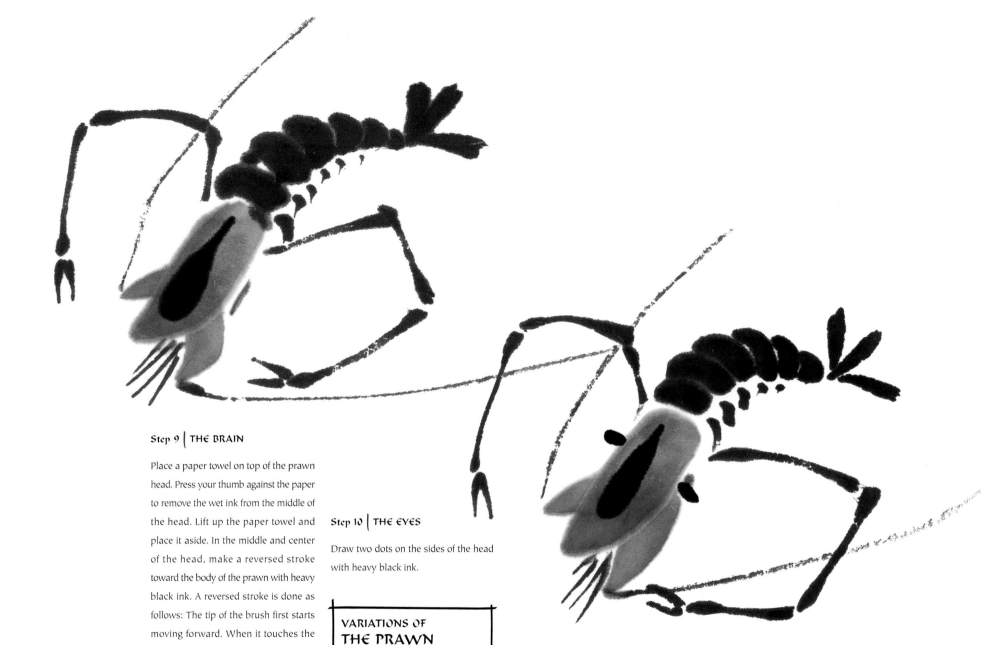

Step 9 | THE BRAIN

Place a paper towel on top of the prawn head. Press your thumb against the paper to remove the wet ink from the middle of the head. Lift up the paper towel and place it aside. In the middle and center of the head, make a reversed stroke toward the body of the prawn with heavy black ink. A reversed stroke is done as follows: The tip of the brush first starts moving forward. When it touches the paper, press it down and reverse course by moving it in the opposite direction. Gradual lift the brush up, with the tip of the brush still in the center. The result is a stroke that looks like an exclamation mark without a dot.

Step 10 | THE EYES

Draw two dots on the sides of the head with heavy black ink.

VARIATIONS OF
THE PRAWN

The gestures of the prawn can vary. The arms can stretch forward or bend to form a circle. The body can be curved or straight. Practice drawing the prawn in different tones of ink and in various postures.

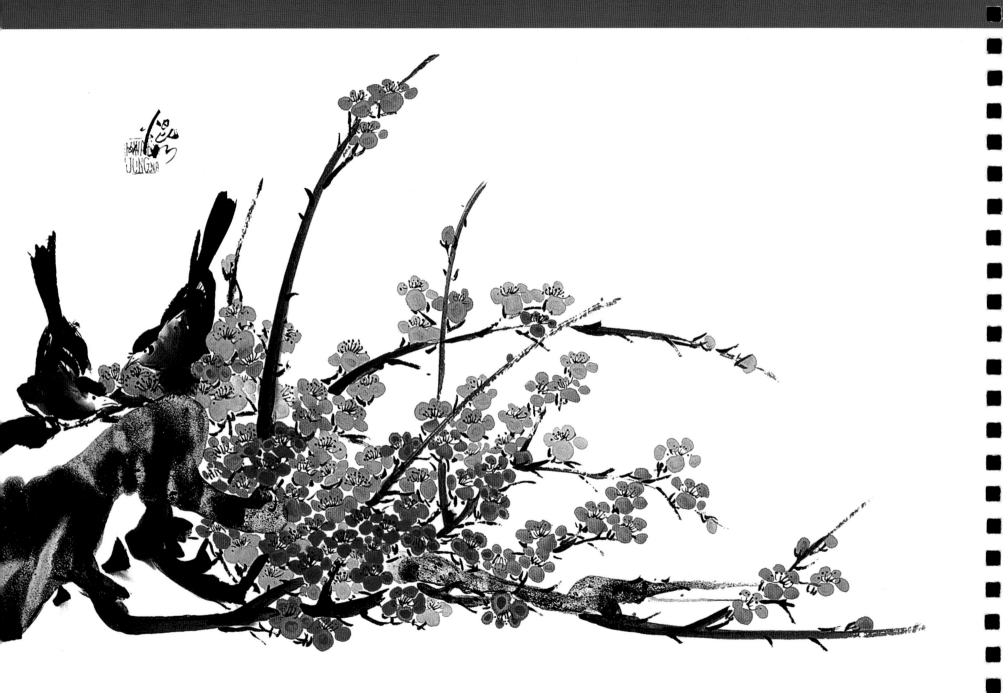

CREATING BRUSH PAINTINGS, STEP BY STEP

2

In art school, the prerequisite for any painting class is usually the drawing class. Drawing teaches the artist how to make quick sketches on paper with a pencil or charcoal sticks. The topics for drawing include composition, scale, proportion, balance, negative space, etc. It is similar to learning Chinese brush painting. However, you are drawing on a piece of rice paper with a wet bamboo brush rather than using a pencil on drawing paper. It is not easy to work with the wet brush, even for those who have experience. The following step-by-step lessons will teach you how to draw pictures with a bamboo brush. There are many brushwork lessons and brushstrokes of all kinds to practice in each lesson. After completing these twelve lessons, I am quite sure that you will have no difficulty creating your own brush paintings.

RED PLUM, WHITE SNOW AND MAGPIES
Acrylic
17" x 26" (43cm x 66cm)

THE SWALLOW

The swift wings of the flying swallow call for fast-action strokes to suggest movement. The dancing gestures of the bird in the air suggest a vigorous pose. The flight and actions of the swallow, through interpretive brushwork, can be accomplished in a few suggestive strokes, creating a picture that is uplifting and deeply satisfying. A painting of swallows accompanied by peach flowers is often seen in brush painting. The brushwork used to interpret a swallow is similar to the brushwork used to paint a bamboo leaf. We often find that similar brushstrokes may be used to interpret different subjects.

Head, Wing and Tail, Beak, Body, Eye

The swallow can be painted with two tones of ink and four different brushstrokes.

GLIDING, FLYING, LANDING

The postures of the swallow are many: flying, gliding, swooping down, landing, etc. Try to pose the bird in different airborne positions in one painting.

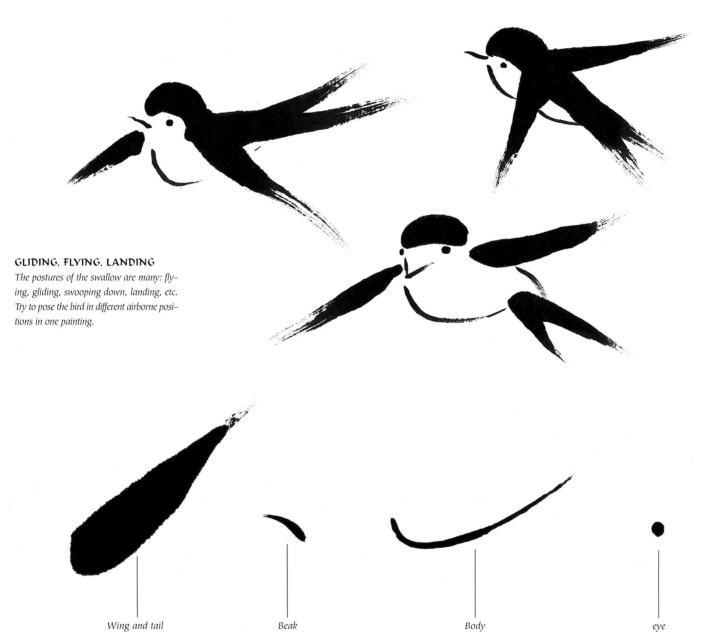

Head Wing and tail Beak Body eye

Step 1 | THE HEAD

Soak the brush with dark ink. Hold the brush using the vertical lock-in hold. Press the tip of the brush onto the paper leaning to the right-hand side. Lift up the brush immediately.

Step 2 | THE FIRST WING

Soak the brush with dark ink. Hold the brush using the vertical lock-in hold. Press the tip down and move away from the head, forming the wing. Gradually lift the brush, ending with a sharp point.

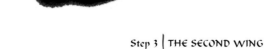

Step 3 | THE SECOND WING

Create the second wing using the same technique you used for the first wing. Place it above the first wing, slightly behind the head.

Step 4 | THE FIRST TAIL

Paint the tail using the same technique used for the wings. Place this between the two wings.

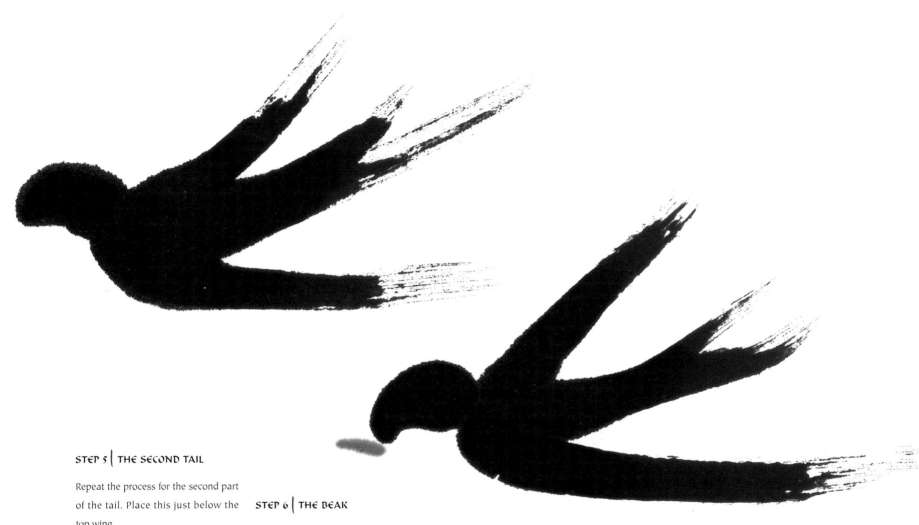

STEP 5 | THE SECOND TAIL

Repeat the process for the second part of the tail. Place this just below the top wing.

STEP 6 | THE BEAK

Load the brush tip with diluted ink. Use a paper towel to soak up the ink from the brush until the bristles are almost dry. Gently dip the tip of the brush to the paper to draw the beak with one downward line.

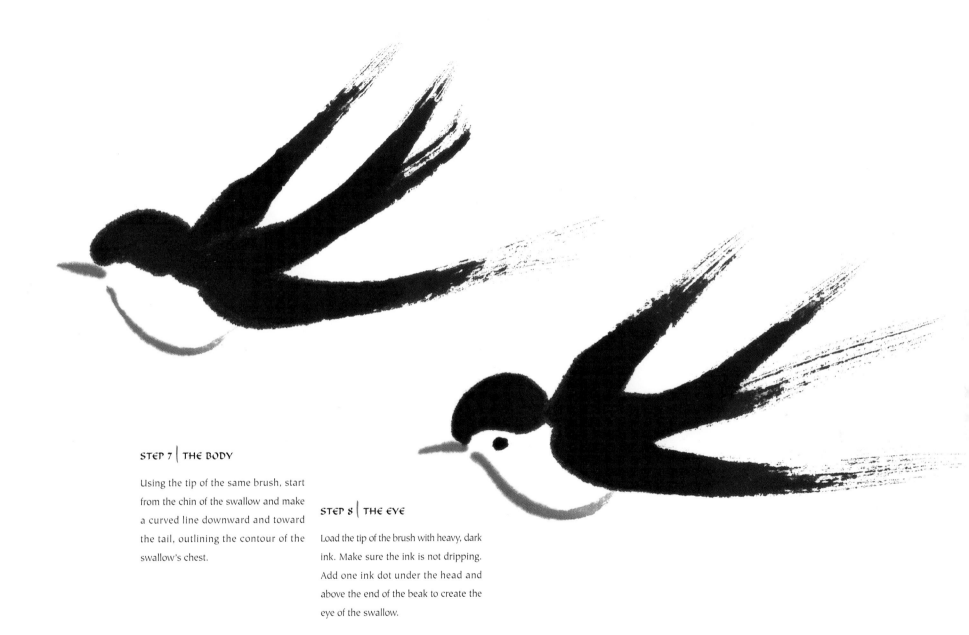

STEP 7 | THE BODY

Using the tip of the same brush, start
from the chin of the swallow and make
a curved line downward and toward
the tail, outlining the contour of the
swallow's chest.

STEP 8 | THE EYE

Load the tip of the brush with heavy, dark
ink. Make sure the ink is not dripping.
Add one ink dot under the head and
above the end of the beak to create the
eye of the swallow.

CREATE A SENSE OF FLIGHT

Place the swallows above the top of the tree line to suggest that the birds are flying high in the sky.

SWALLOW
Ink
10" x 11" (25cm x 28cm)

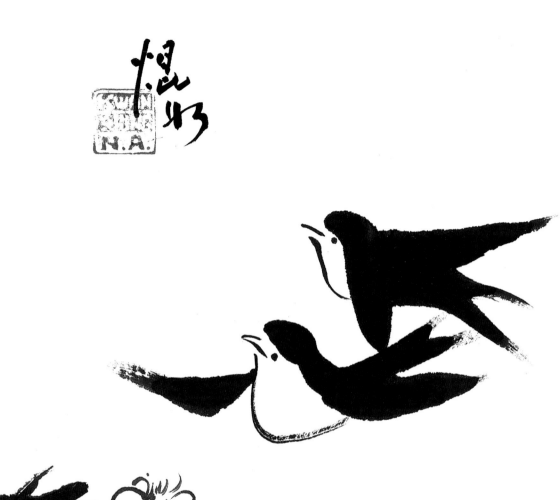

COMBINING ELEMENTS

Place the swallows and peach flowers together to reflect the season—spring.

SWALLOW BIRD AND PEACH FLOWER
Watercolor
19" x 12" (48cm x 30cm)

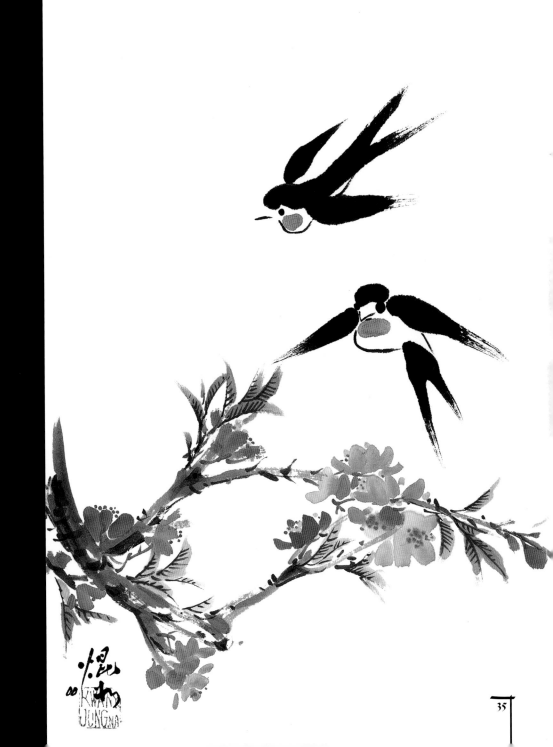

BAMBOO

The four most commonly painted subjects in Chinese brush painting are bamboo, orchids, plum blossoms and chrysanthemums. In art, these are known as the Four Gentlemen Paintings. Each one of them delivers a philosophical statement. Bamboo exemplifies the man who has an open mind and integrity, who is humble and has a straightforward personality.

Bamboo offers us the opportunity to practice straight and short brushwork. Several forms of the straight stroke are used to create the impression of the bamboo tree. Each stroke takes a unique form in order to capture the essential characteristics of the plant. Tree trunk, trunk nodes, stems, branches and leaves each have their own unique form. They are straight, short, strong and repetitious.

STEP 1 | THE TREE TRUNK

Soak the brush with a light-value, diluted ink. Put the tip of the brush down with the tip pointing outward. Press down to form the desired size of the tree trunk. Turn the brush counterclockwise 90 degrees. With the tip of the brush, draw the center to make a line of desired length and stop. Turn the brush back with the tip pointing outward again and lift the brush up immediately. Repeat these actions to make a long bamboo stick. The brush remains in the vertical position at all times. The result of this vertical stroke is a substantial, rounded line.

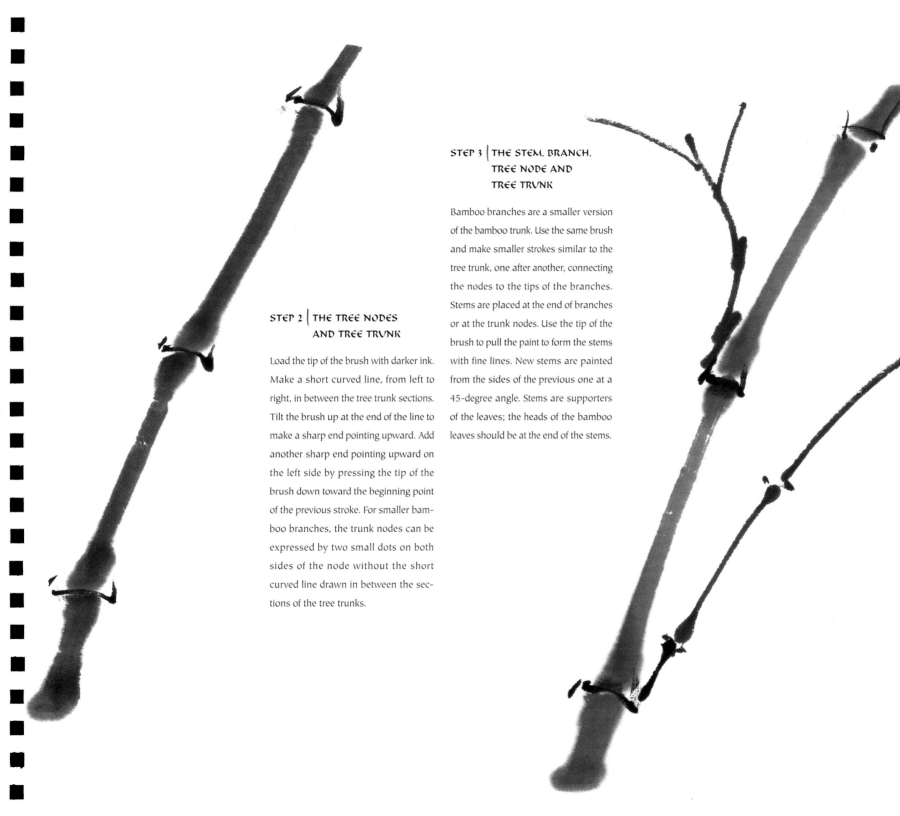

STEP 2 | THE TREE NODES AND TREE TRUNK

Load the tip of the brush with darker ink. Make a short curved line, from left to right, in between the tree trunk sections. Tilt the brush up at the end of the line to make a sharp end pointing upward. Add another sharp end pointing upward on the left side by pressing the tip of the brush down toward the beginning point of the previous stroke. For smaller bamboo branches, the trunk nodes can be expressed by two small dots on both sides of the node without the short curved line drawn in between the sections of the tree trunks.

STEP 3 | THE STEM, BRANCH, TREE NODE AND TREE TRUNK

Bamboo branches are a smaller version of the bamboo trunk. Use the same brush and make smaller strokes similar to the tree trunk, one after another, connecting the nodes to the tips of the branches. Stems are placed at the end of branches or at the trunk nodes. Use the tip of the brush to pull the paint to form the stems with fine lines. New stems are painted from the sides of the previous one at a 45-degree angle. Stems are supporters of the leaves; the heads of the bamboo leaves should be at the end of the stems.

STEP 4 | ONE LEAF

On a separate piece of paper, practice making leaves. Soak the brush with an ample amount of heavy dark ink. Press the tip of the brush to the paper. Move slightly to the left, then move to the right and strike upward. (Or move the tip of the brush backward. Pressing down, move forward and strike.) Each time, lift the brush up quickly with the tip of the brush in the center. Reverse this action, keeping the brush vertical, so the head of the leaf will be round and the tail will have a sharp pointed end.

STEP 5 | TWO LEAVES

Repeat the techniques as in step 4, but in a slightly different direction.

STEP 6 | THREE LEAVES

Bamboo painting compositions most frequently take a triangular form. There are triangles between the branches and stems, as well as between individual leaves and clusters.

Learn to form clusters of bamboo leaves by following the formation of leaves on page 39.

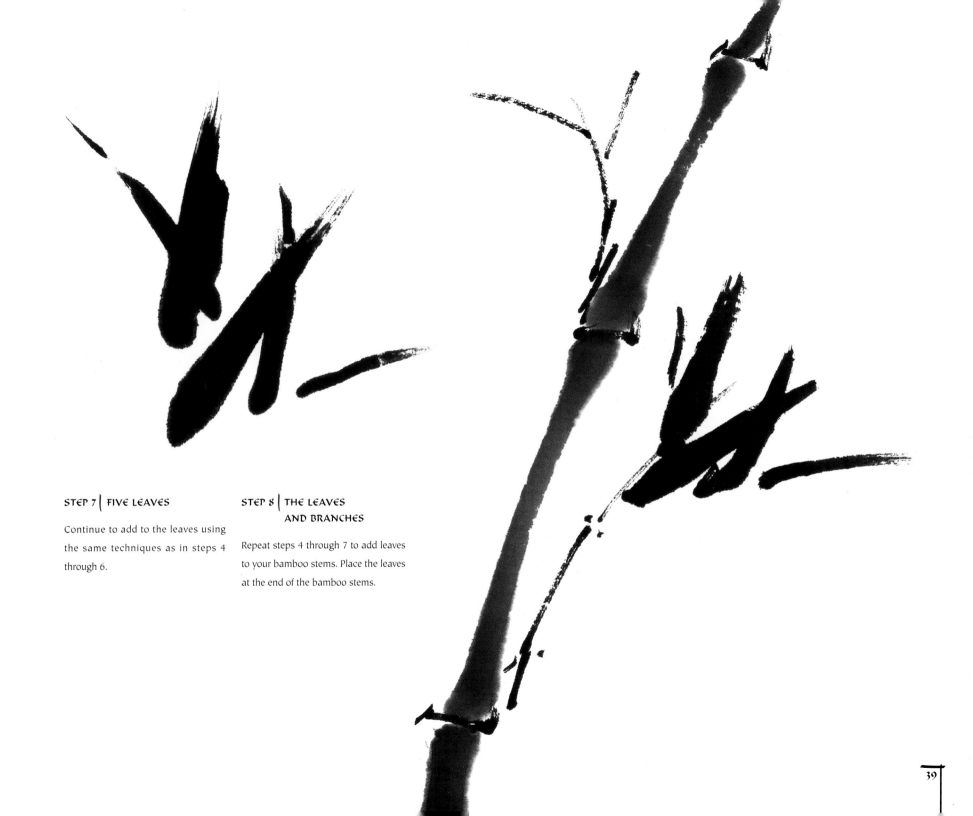

STEP 7 | FIVE LEAVES

Continue to add to the leaves using the same techniques as in steps 4 through 6.

STEP 8 | THE LEAVES AND BRANCHES

Repeat steps 4 through 7 to add leaves to your bamboo stems. Place the leaves at the end of the bamboo stems.

39

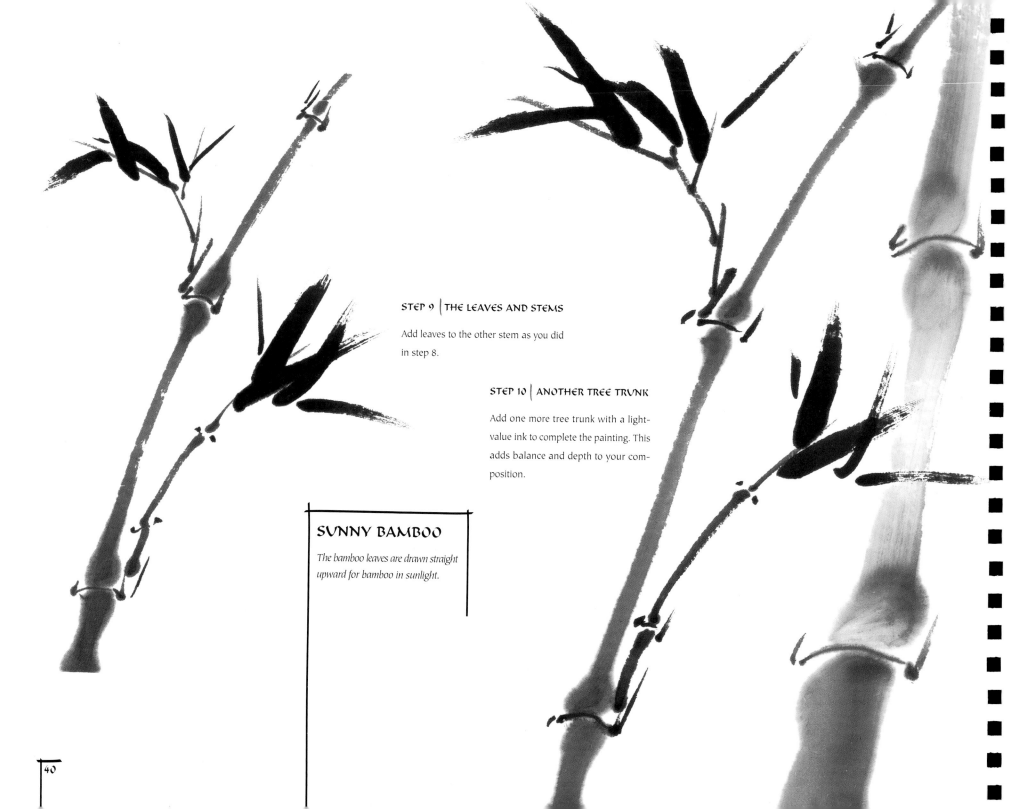

STEP 9 | THE LEAVES AND STEMS

Add leaves to the other stem as you did in step 8.

STEP 10 | ANOTHER TREE TRUNK

Add one more tree trunk with a light-value ink to complete the painting. This adds balance and depth to your composition.

SUNNY BAMBOO

The bamboo leaves are drawn straight upward for bamboo in sunlight.

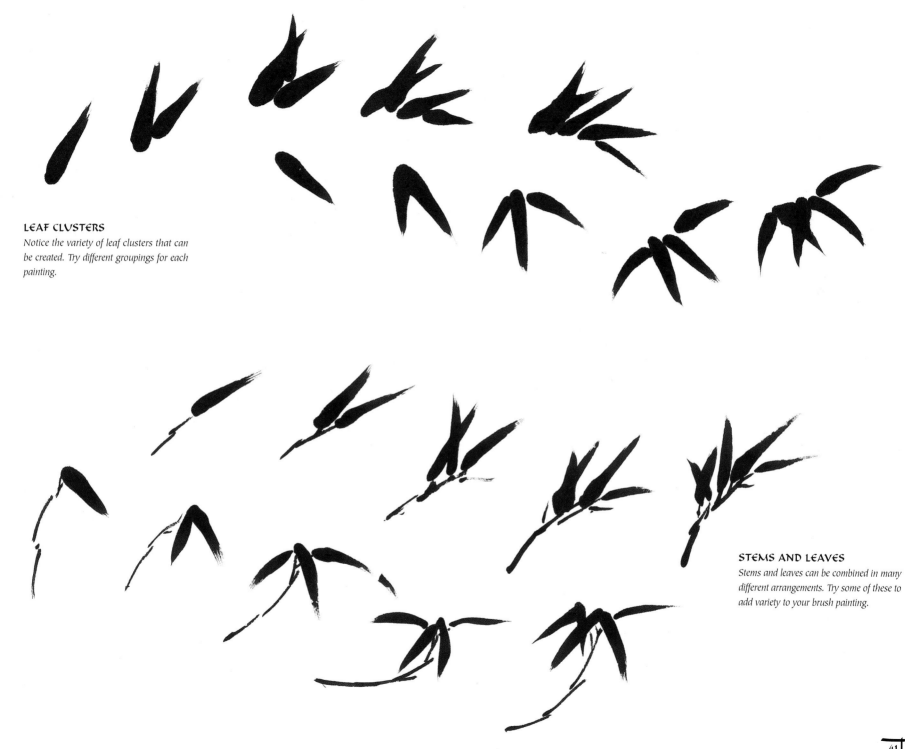

LEAF CLUSTERS

Notice the variety of leaf clusters that can be created. Try different groupings for each painting.

STEMS AND LEAVES

Stems and leaves can be combined in many different arrangements. Try some of these to add variety to your brush painting.

41

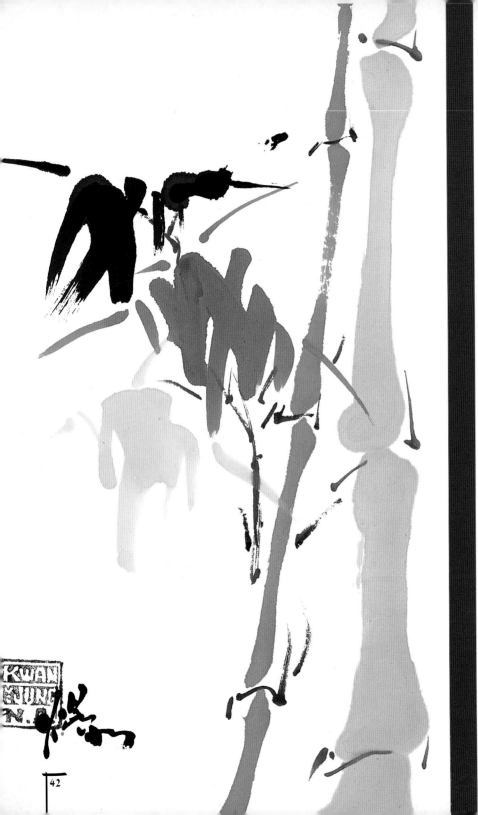

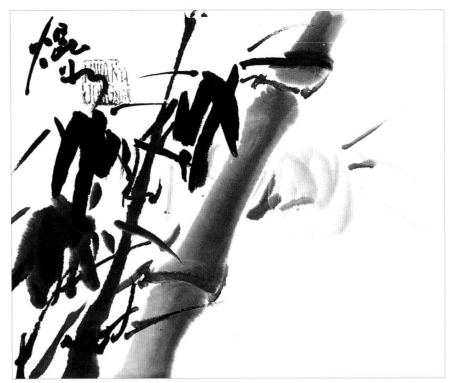

BAMBOO IN COLOR

Work from light yellow to green, adding the ink as the final touch in painting bamboo leaves. The bamboo trunk is painted from deep to light value using vertical strokes.

BAMBOO IN COLOR
Ink and watercolor
13" x 9" (33cm x 23cm)

RAINY BAMBOO

Use wet strokes to paint leaves downward, with many different values of ink to depict the condition of bamboo in the rain.

RAINY BAMBOO
Ink
8" x 9" (20cm x 23cm)

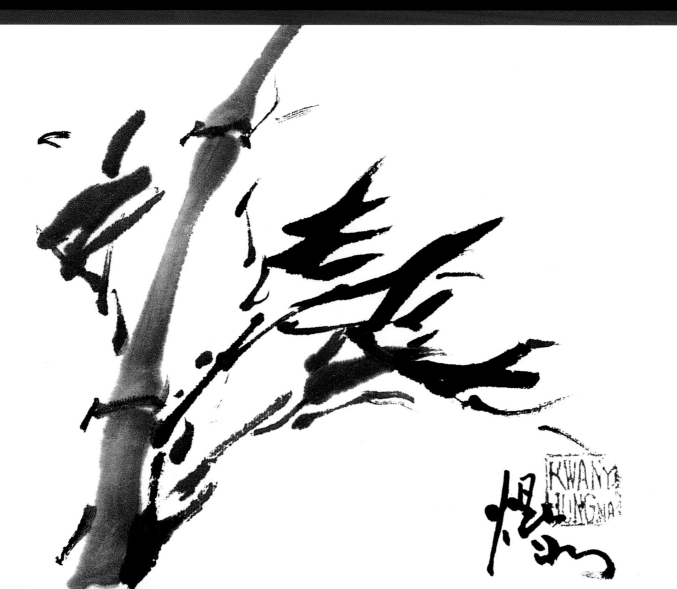

WIND BLOWN BAMBOO
Bamboo leaves painted sideways depict the blowing wind.

WINDY BAMBOO
Ink
8" x 9" (20cm x 23cm)

BAMBOO LEAVES

Many variations of ink are used to paint bamboo leaves, with the darkest value of ink for the closest leaves and the lightest ink to paint those leaves in the distance. Weather conditions may be depicted by the directional flow of the leaves.

WILD ORCHID

The orchid is the second gentleman of Chinese brush painting. He represents the individual who can live the simple monastic life in the mountains, free from the luxuries and entertainment of the city. Long curved strokes are the primary means of painting orchid leaves. These strokes are different from the straightforward short brushwork used in painting bamboo; the leaves of the orchid are drawn with long curved strokes. They are gentle in mood yet full of strength. When painting, one may think of the eyelids of a beautiful girl and draw the contour of her eyes. First, paint the long curved leaves, then the flowers.

There are four different types of brushwork for making an orchid painting: (1) blade shape leaves, (2) flower petals, (3) eye dots, and (4) stems. Only two tones of ink are needed—dark and light.

Only three blades are needed for a simple wild orchid flower. Long curved lines are painted using the vertical lock-in hold. Use swift up-and-down motions to form strokes—starting at the ground, moving toward the sky and then curving downward toward the ground again. This is the basic structural design for an orchid.

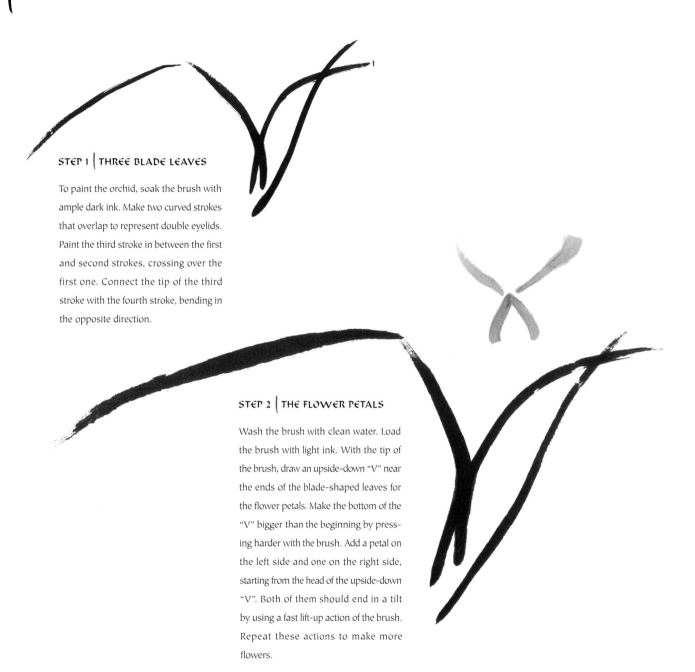

STEP 1 | THREE BLADE LEAVES

To paint the orchid, soak the brush with ample dark ink. Make two curved strokes that overlap to represent double eyelids. Paint the third stroke in between the first and second strokes, crossing over the first one. Connect the tip of the third stroke with the fourth stroke, bending in the opposite direction.

STEP 2 | THE FLOWER PETALS

Wash the brush with clean water. Load the brush with light ink. With the tip of the brush, draw an upside-down "V" near the ends of the blade-shaped leaves for the flower petals. Make the bottom of the "V" bigger than the beginning by pressing harder with the brush. Add a petal on the left side and one on the right side, starting from the head of the upside-down "V". Both of them should end in a tilt by using a fast lift-up action of the brush. Repeat these actions to make more flowers.

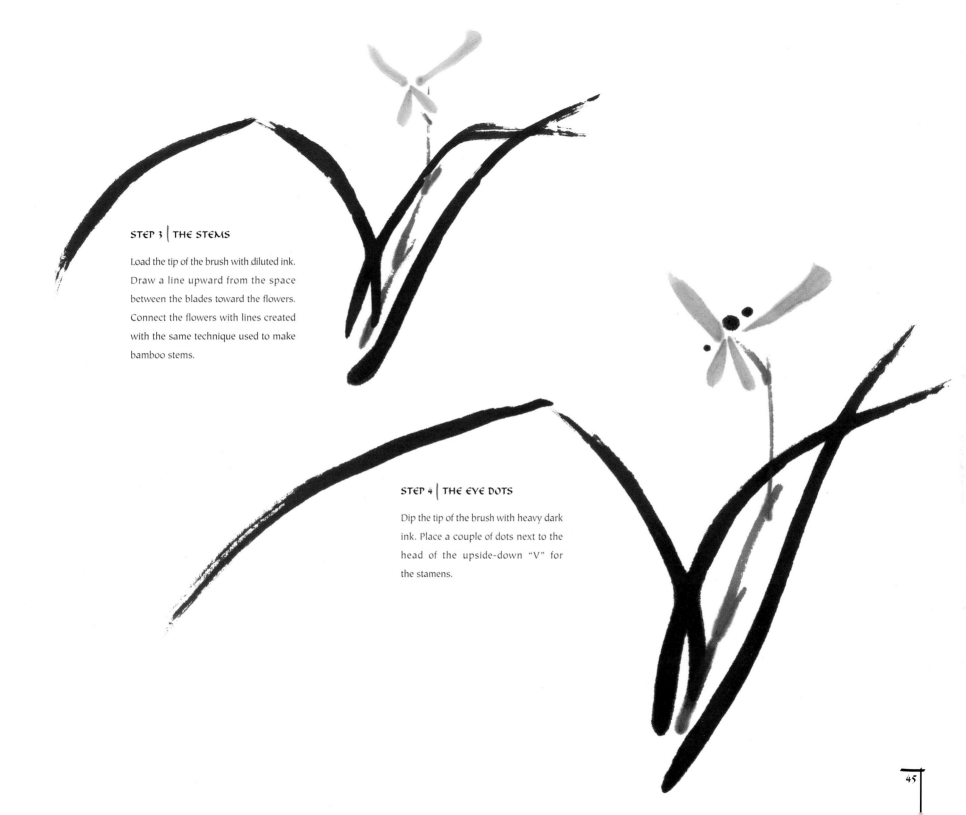

STEP 3 | THE STEMS

Load the tip of the brush with diluted ink. Draw a line upward from the space between the blades toward the flowers. Connect the flowers with lines created with the same technique used to make bamboo stems.

STEP 4 | THE EYE DOTS

Dip the tip of the brush with heavy dark ink. Place a couple of dots next to the head of the upside-down "V" for the stamens.

45

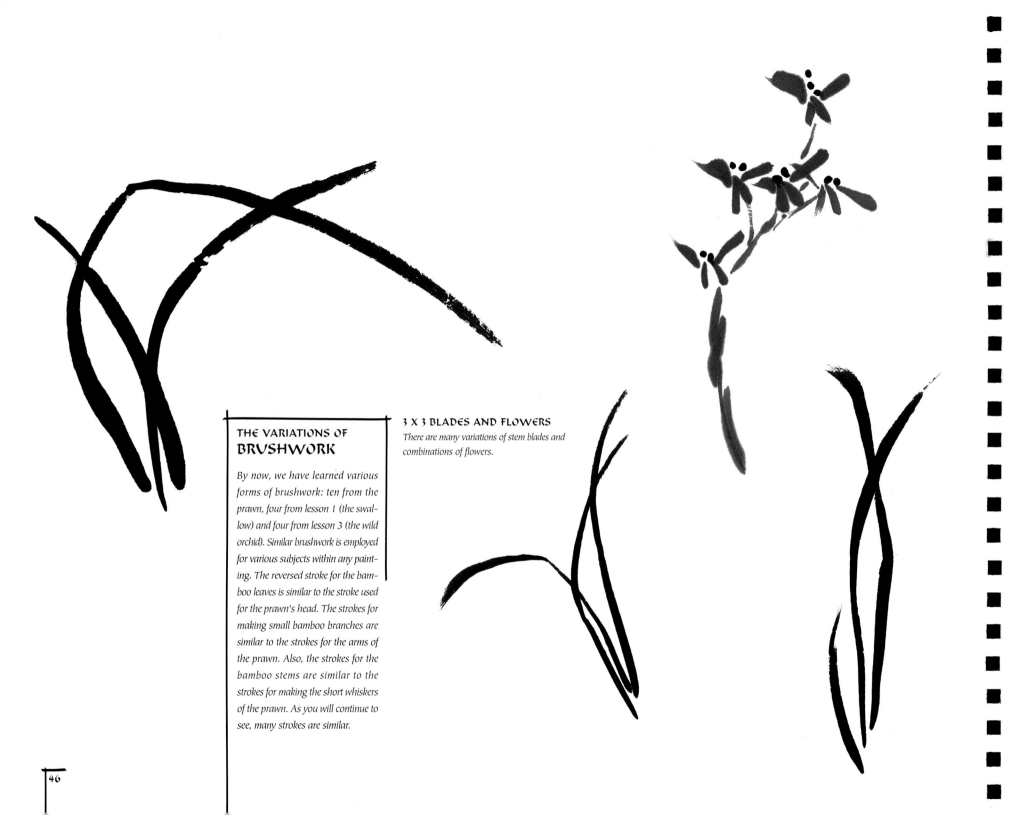

THE VARIATIONS OF
BRUSHWORK

By now, we have learned various forms of brushwork: ten from the prawn, four from lesson 1 (the swallow) and four from lesson 3 (the wild orchid). Similar brushwork is employed for various subjects within any painting. The reversed stroke for the bamboo leaves is similar to the stroke used for the prawn's head. The strokes for making small bamboo branches are similar to the strokes for the arms of the prawn. Also, the strokes for the bamboo stems are similar to the strokes for making the short whiskers of the prawn. As you will continue to see, many strokes are similar.

3 X 3 BLADES AND FLOWERS

There are many variations of stem blades and combinations of flowers.

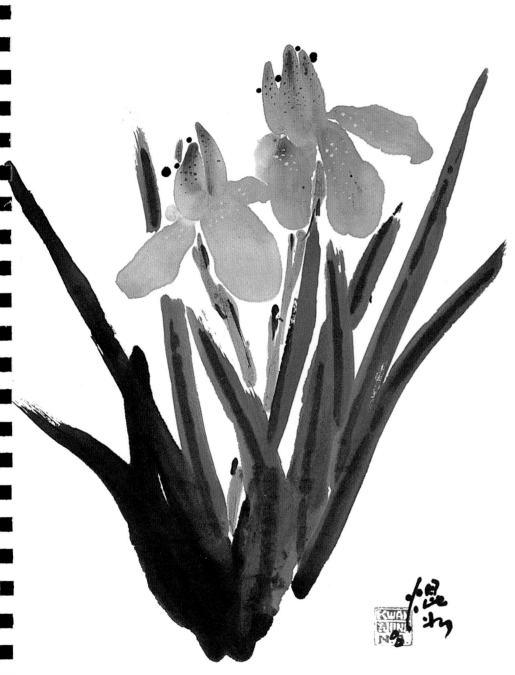

BLOWING LEAVES

To depict the orchid leaves blowing in the wind, the brush should have up-and-down motions when painting the long curved strokes.

THE IRIS FLOWER

The flower petals of the iris are painted in the same manner as the flower petals of the wild orchid. Light-value colors are used in this painting. The color combinations of orange and violet, as well as blue and purple, were used for the flower petals.

Some long blade leaves around the bottoms of the flower petals were added using blue and blue combined with ink. A heavy ink line in the center of every leaf was added. Red and yellow dots were placed inside the flower petals and ink dots beside the tops.

IRIS FLOWER
Acrylic
16" x 14" (41cm x 36cm)

ORCHID IN WIND
Ink
9" x 11" (23cm x 28cm)

USE ORCHID LEAVES FOR OTHER PLANTS

The leaves of other plants such as irises, grasses and marsh reeds, may be painted similarly with the up-and-down, long curved stroke used for orchid leaves. Make every leaf point in a different direction. One may slightly cross the other. They should never be parallel. Remember to create the eyelid shape.

PLUM BLOSSOM

Plum blossoms bloom in the late winter. They symbolize the third gentleman of Chinese brush painting. He is the kind of person who can create fine things in the midst of adversity. The plum tree branches are characterized by the rough, sharp and harsh textures of the bark. They are rendered in irregular left-and-right strokes to suggest their rigidity. This sketchlike appearance is not intended to be refined; it is an attempt to capture the essential characteristics of the tree branches. These strokes are the basis for how to paint the tree.

First, the tree branches are drawn with the irregular left-and-right strokes, followed by the flower. The plum flower requires circular strokes. Openings may be left in the branches to provide spaces for the flowers to intersect them. The contrast of the dark harsh branches and the soft white flowers show the very essence of brush painting.

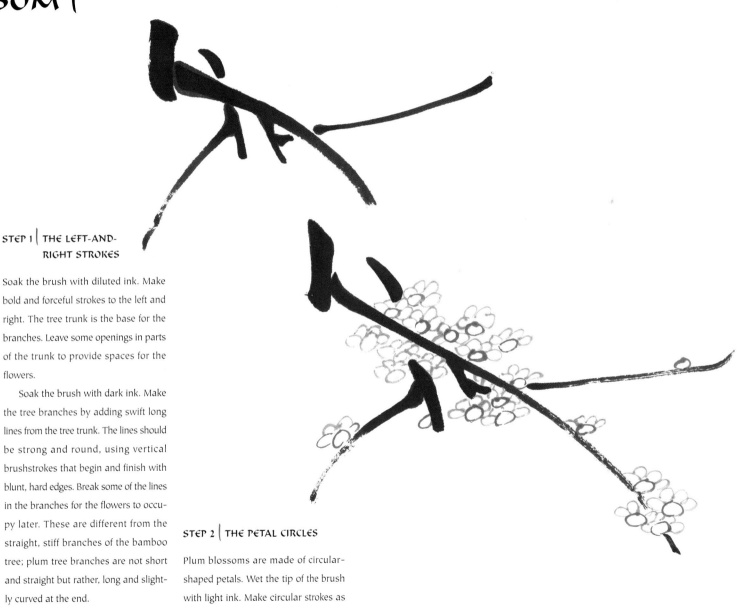

STEP 1 | THE LEFT-AND-RIGHT STROKES

Soak the brush with diluted ink. Make bold and forceful strokes to the left and right. The tree trunk is the base for the branches. Leave some openings in parts of the trunk to provide spaces for the flowers.

Soak the brush with dark ink. Make the tree branches by adding swift long lines from the tree trunk. The lines should be strong and round, using vertical brushstrokes that begin and finish with blunt, hard edges. Break some of the lines in the branches for the flowers to occupy later. These are different from the straight, stiff branches of the bamboo tree; plum tree branches are not short and straight but rather, long and slightly curved at the end.

STEP 2 | THE PETAL CIRCLES

Plum blossoms are made of circular-shaped petals. Wet the tip of the brush with light ink. Make circular strokes as blobs and petals.

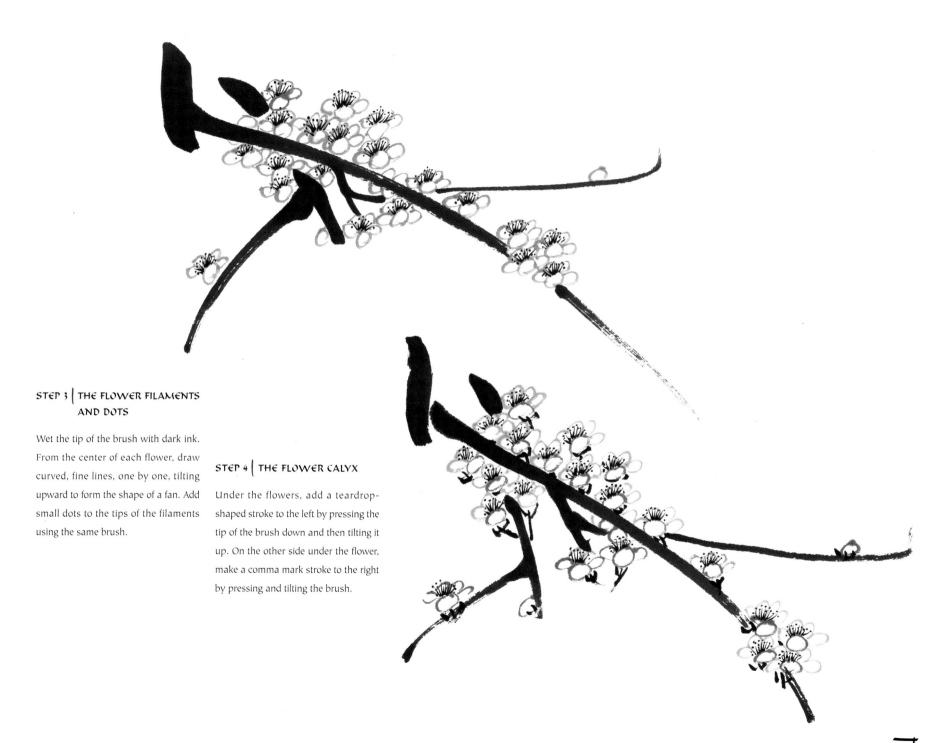

STEP 3 | THE FLOWER FILAMENTS AND DOTS

Wet the tip of the brush with dark ink. From the center of each flower, draw curved, fine lines, one by one, tilting upward to form the shape of a fan. Add small dots to the tips of the filaments using the same brush.

STEP 4 | THE FLOWER CALYX

Under the flowers, add a teardrop-shaped stroke to the left by pressing the tip of the brush down and then tilting it up. On the other side under the flower, make a comma mark stroke to the right by pressing and tilting the brush.

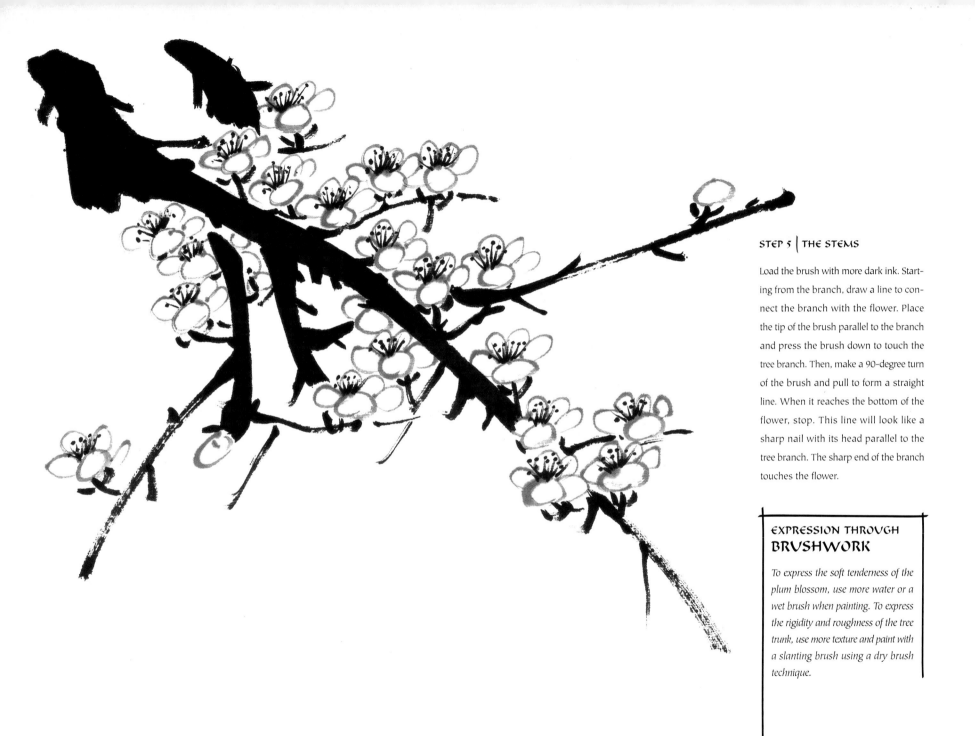

STEP 5 | THE STEMS

Load the brush with more dark ink. Starting from the branch, draw a line to connect the branch with the flower. Place the tip of the brush parallel to the branch and press the brush down to touch the tree branch. Then, make a 90-degree turn of the brush and pull to form a straight line. When it reaches the bottom of the flower, stop. This line will look like a sharp nail with its head parallel to the tree branch. The sharp end of the branch touches the flower.

EXPRESSION THROUGH
BRUSHWORK

To express the soft tenderness of the plum blossom, use more water or a wet brush when painting. To express the rigidity and roughness of the tree trunk, use more texture and paint with a slanting brush using a dry brush technique.

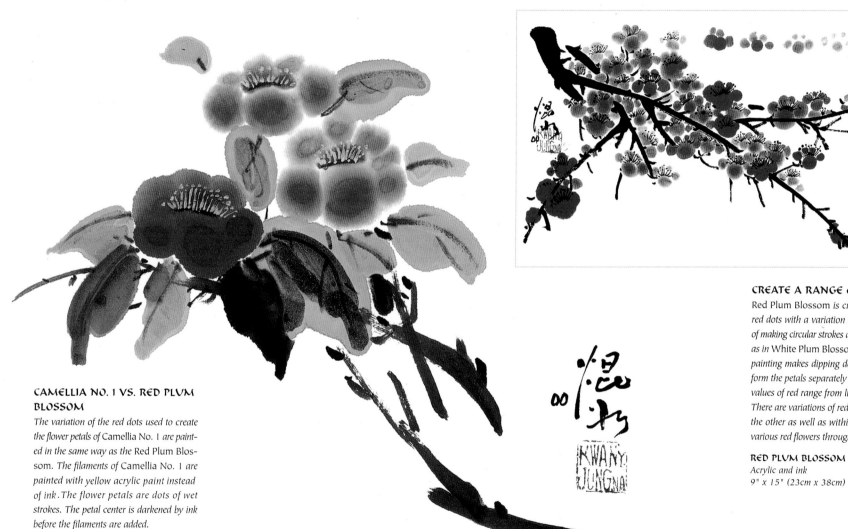

CAMELLIA NO. 1 VS. RED PLUM BLOSSOM

The variation of the red dots used to create the flower petals of Camellia No. 1 are painted in the same way as the Red Plum Blossom. The filaments of Camellia No. 1 are painted with yellow acrylic paint instead of ink. The flower petals are dots of wet strokes. The petal center is darkened by ink before the filaments are added.

CAMELLIA NO. 1
Acrylic
13" x 14" (33cm x 36cm)

CREATE A RANGE OF VALUES

Red Plum Blossom *is created from many red dots with a variation of values. Instead of making circular strokes as blobs and petals as in* White Plum Blossom *(page 50), this painting makes dipping dots big enough to form the petals separately one by one. Deep values of red range from light to full values. There are variations of red from one petal to the other as well as within one flower and various red flowers throughout the painting.*

RED PLUM BLOSSOM
Acrylic and ink
9" x 15" (23cm x 38cm)

CHRYSANTHEMUMS

The most popular subject of the four gentlemen painting is the chrysanthemum. Chrysanthemums represent the common man who is a good, unpretentious person. This flower comes in innumerable forms and a wide variety of colors. It is easily planted and grows everywhere, making it a popular subject for many artists.

To draw the chrysanthemum bloom, the artist outlines the flower contour petal by petal. One may notice that there are many different shapes of petals for different species of chrysanthemums. Short, long, narrow, fat, straight, curved and circular—each form giving us endless brushwork possibilities when painting chrysanthemums.

After the form of the petals is decided, the artist fills in the specific color of the chrysanthemum as desired. By painting the chrysanthemum, you gain experience in contour drawing of subjects with the tip of the brush. Another useful experience gained by painting chrysanthemums is learning how to paint leaves.

CHRYSANTHEMUM LEAVES: A QUICK EXPLANATION

Leaves are painted by holding the brush near the center of the handle using a light-value ink or color. Chrysanthemum leaves are straight. They resemble the shape of maple leaves but are slender, slim and narrow. Each leaf has five spoon-shaped prongs. For each leaf, press the brush sideways and then turn the brush downward before lifting up. Paint the leaves after the flower petals are complete.

THREE VARIATIONS OF MUMS

Mums grow in three basic varieties: small petals, long petals and curved petals. Each is unique and beautiful. The leaves are the same no matter what type of petal the mum has. Follow these simple demonstrations to learn how to paint each type.

STEP 1 BEGIN THE FLOWERS

Hold the brush using the lock-in hold, placing your hand close to the bristles. Wet the brush with diluted ink. Begin at the center of the flower and outline the petals with two strokes per petal for the small and curved flowers (a and c). For the long petal flowers (b), place various-sized dots to form a circular shape. Copy the shape of the original flower petals as much as possible. Arrange the petals, one next to another, in a circle.

STEP 2 ENLARGE THE FLOWERS

Gradually enlarge the flowers by adding another circle of petals, one by one, at the edge of previous ones.

STEP 3 COMPLETE THE PETALS

Repeat the previous steps of outlining and enlarging the petals until the flowers are fully painted.

a. small petals

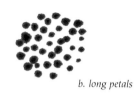

b. long petals

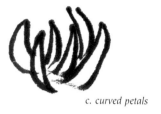

c. curved petals

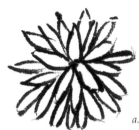

a.

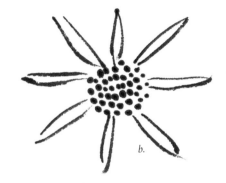

b.

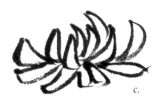

c.

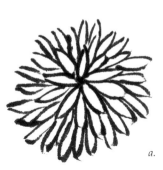

a.

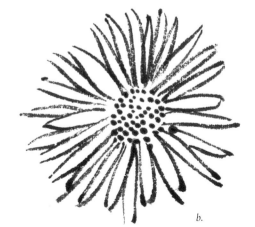

b.

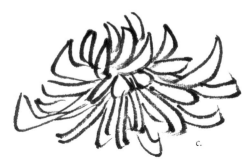

c.

SMALL PETAL MUM

This quick and easy demonstration will show you how to combine a small petal mum with leaves to create a flower.

STEP 2 | PAINT THE LEAVES

Soak the brush with ink. Remember to paint the leaves in the direction they would grow. Use dark ink and full force when making your leaves.

STEP 3 | ADD THE LEAF VEINS

Use heavy dark ink to draw and outline the veins in each leaf.

STEP 1 | CREATE FLOWER AND BRANCH

Create a flower with small petals using the technique learned on page 53. Dip the brush tip with a diluted mixture of color or ink. Paint the branch beginning at the edge of the paper moving toward the flower.

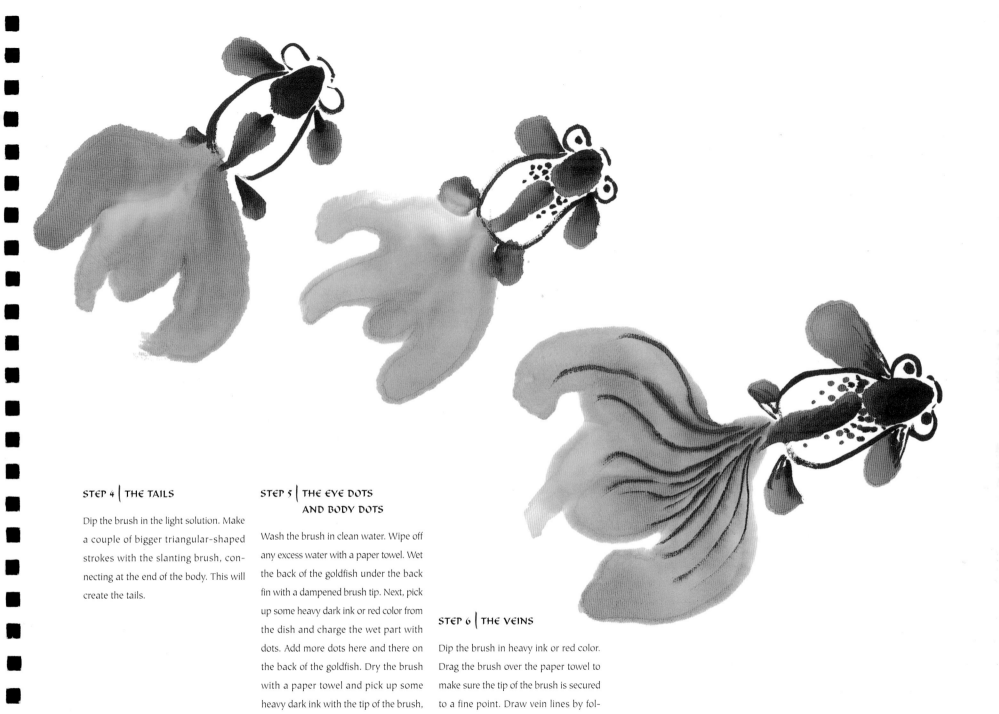

STEP 4 | THE TAILS

Dip the brush in the light solution. Make a couple of bigger triangular-shaped strokes with the slanting brush, connecting at the end of the body. This will create the tails.

STEP 5 | THE EYE DOTS AND BODY DOTS

Wash the brush in clean water. Wipe off any excess water with a paper towel. Wet the back of the goldfish under the back fin with a dampened brush tip. Next, pick up some heavy dark ink or red color from the dish and charge the wet part with dots. Add more dots here and there on the back of the goldfish. Dry the brush with a paper towel and pick up some heavy dark ink with the tip of the brush, and make the eye dots by tipping the brush in the eye sockets.

STEP 6 | THE VEINS

Dip the brush in heavy ink or red color. Drag the brush over the paper towel to make sure the tip of the brush is secured to a fine point. Draw vein lines by following the previous brushwork of the fins and tails.

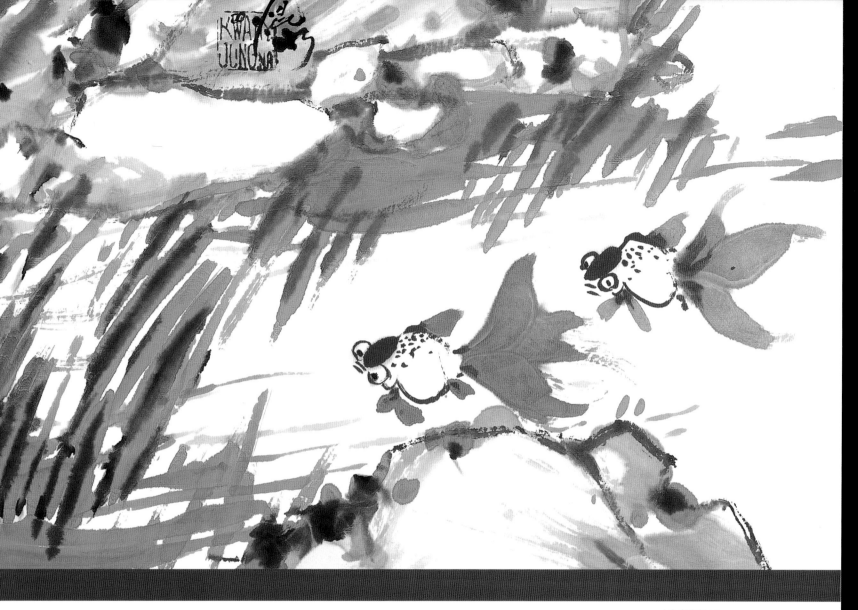

VP STREAM
Watercolor
10" x 15" (25cm x 38cm)

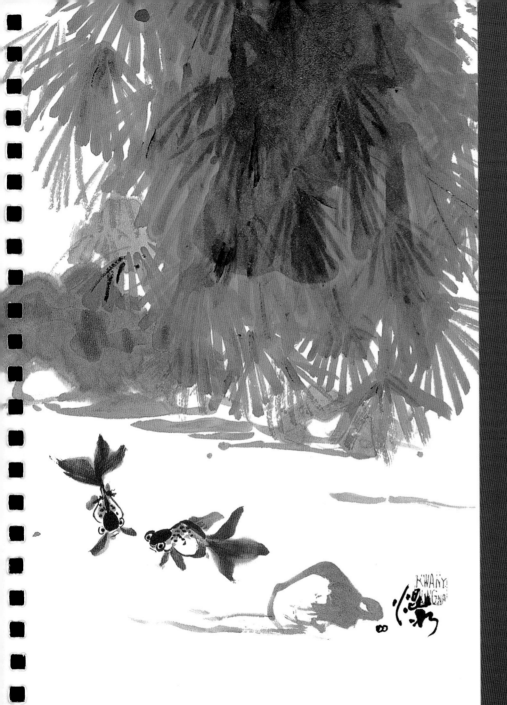

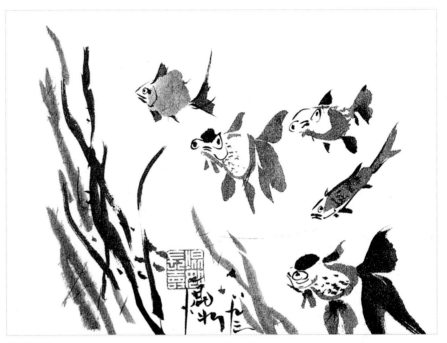

GOLDFISH
Ink
9" x 12" (23cm x 30cm)

PAIR OF GOLD
Acrylic
19" x 15" (48cm x 38cm)

HIBISCUS FLOWERS

To paint a hibiscus flower, mainly use bold smashing and pressing strokes. Other brushstrokes include the dotting strokes for the anther of the stamen, the reversed stroke for the filament stalk, smooth vein lines to emphasize the texture of the flower petals and the left-and-right strokes to form the tree branches. The hibiscus has many colorful flowers. To paint a beautiful hibiscus, ink and various colors are required.

STEP 1 | THE FIRST PETAL

The hibiscus flower has five colorful petals. Soak the brush with high-value Carmine Red for the front petal. Press the tip of the brush down and smash with left-to-right action to form a fan-shaped petal.

STEP 2 | THE SECOND AND THIRD PETALS

Dilute the red color with more water. Dip the brush into the diluted color. Press the tip of the brush above the first petal on the right-hand side and push down to the right to make the second petal. With the same brush, press the tip of the brush above the first petal on the left-hand side and push down to the left to form the third petal.

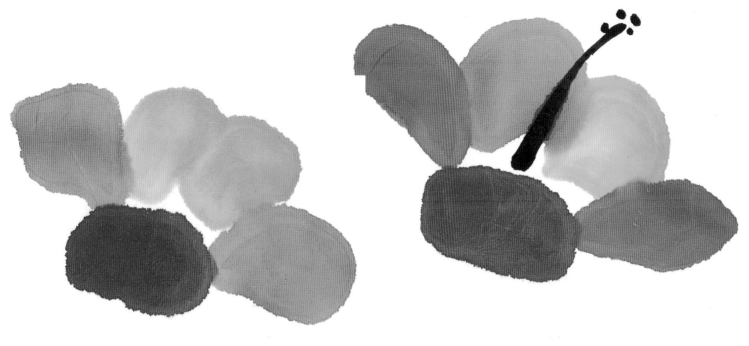

STEP 3 | THE FOURTH AND FIFTH PETALS

Pick up more water with the same brush. Make two more petals with the same smashing action above the center of the flower to complete the circle of petals.

STEP 4 | THE FILAMENT STALK

Dry the brush with a paper towel. Load the brush with a deep red color and ink mixture. In the center of the flower, make a reversed upward stroke to form the filament stalk. Add four or five dots at the tail of the flower filament stalk.

STEP 5 | THE STAMEN

Clean the brush with water and dry it with a paper towel. Load the brush with Cadmium Yellow Medium. Using a dipping action, paint dots around the middle of the filament stalk with heavy yellow pigment.

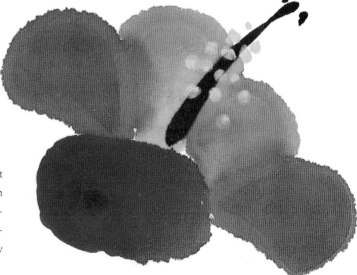

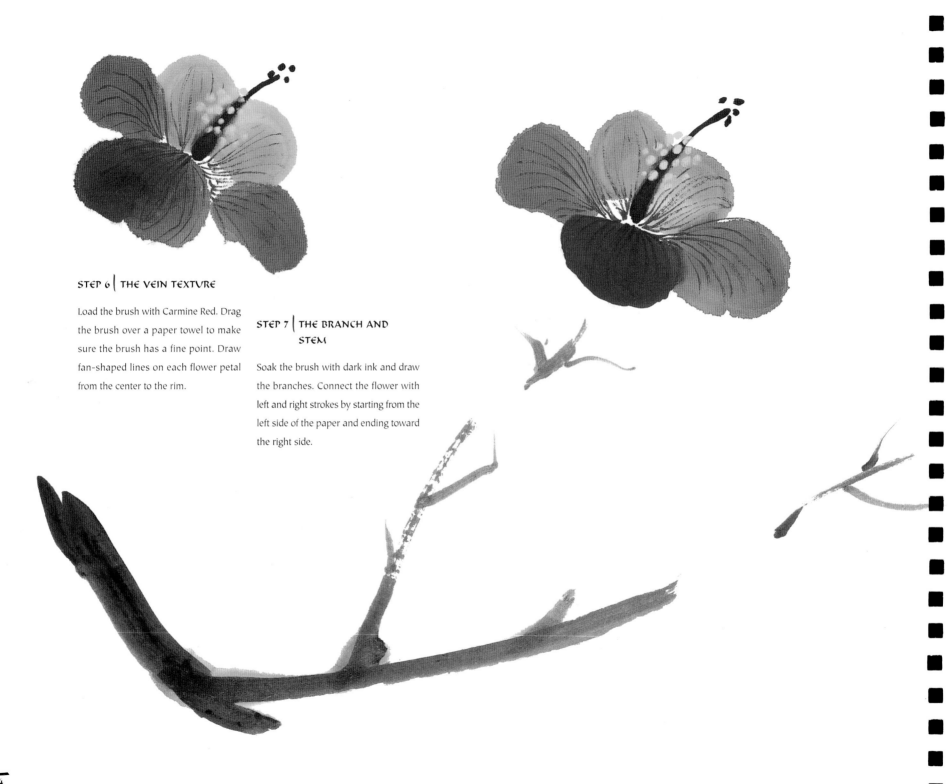

STEP 6 | THE VEIN TEXTURE

Load the brush with Carmine Red. Drag the brush over a paper towel to make sure the brush has a fine point. Draw fan-shaped lines on each flower petal from the center to the rim.

STEP 7 | THE BRANCH AND STEM

Soak the brush with dark ink and draw the branches. Connect the flower with left and right strokes by starting from the left side of the paper and ending toward the right side.

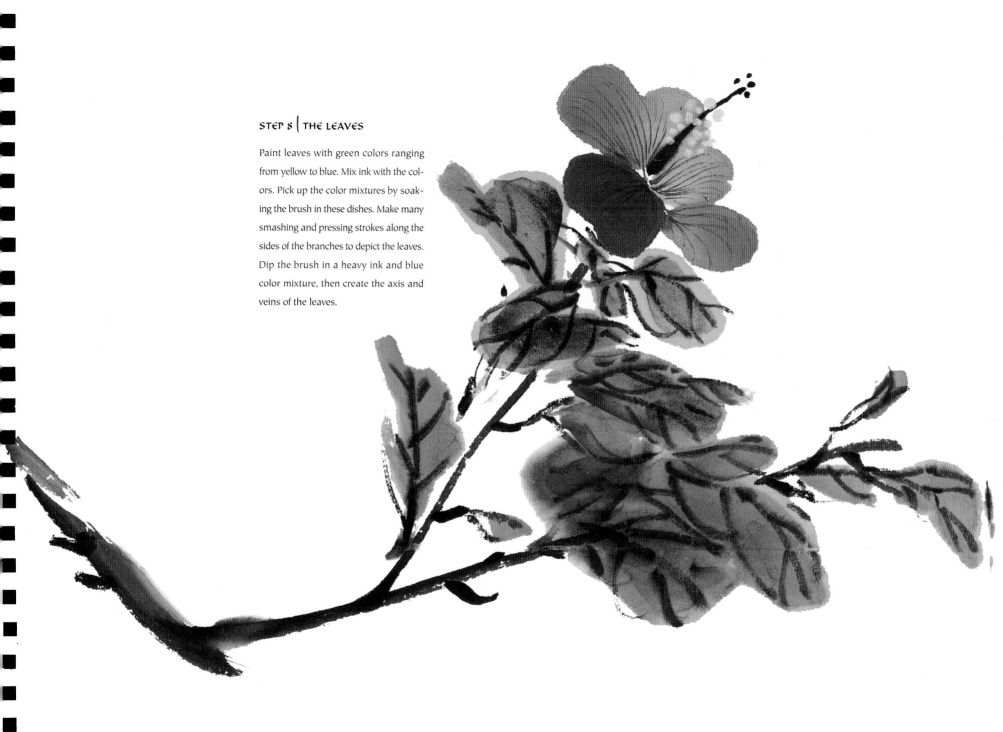

STEP 8 | THE LEAVES

Paint leaves with green colors ranging from yellow to blue. Mix ink with the colors. Pick up the color mixtures by soaking the brush in these dishes. Make many smashing and pressing strokes along the sides of the branches to depict the leaves. Dip the brush in a heavy ink and blue color mixture, then create the axis and veins of the leaves.

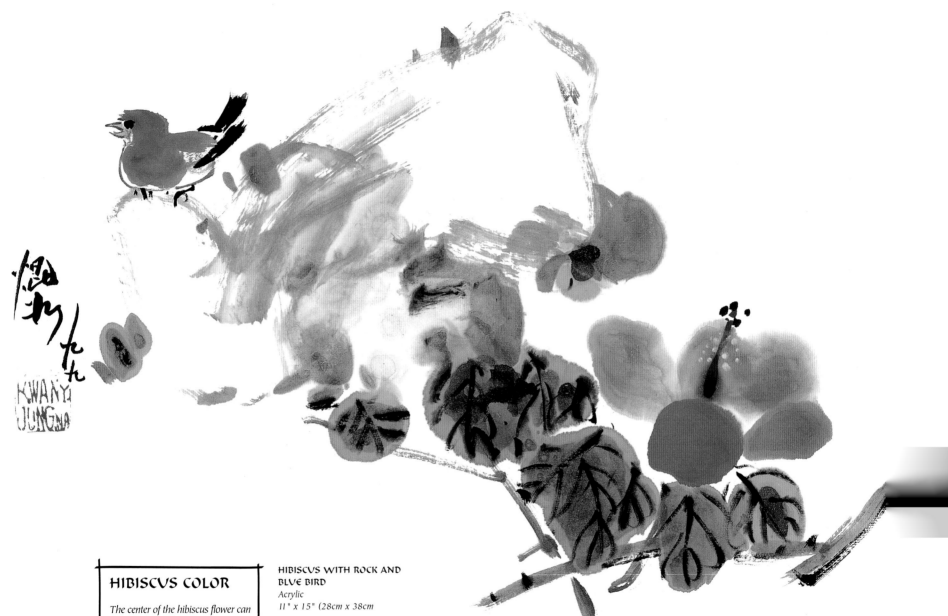

HIBISCVS COLOR

The center of the hibiscus flower can be blank without any color or filled in with a high-value color.

HIBISCVS WITH ROCK AND
BLVE BIRD
Acrylic
11" x 15" (28cm x 38cm

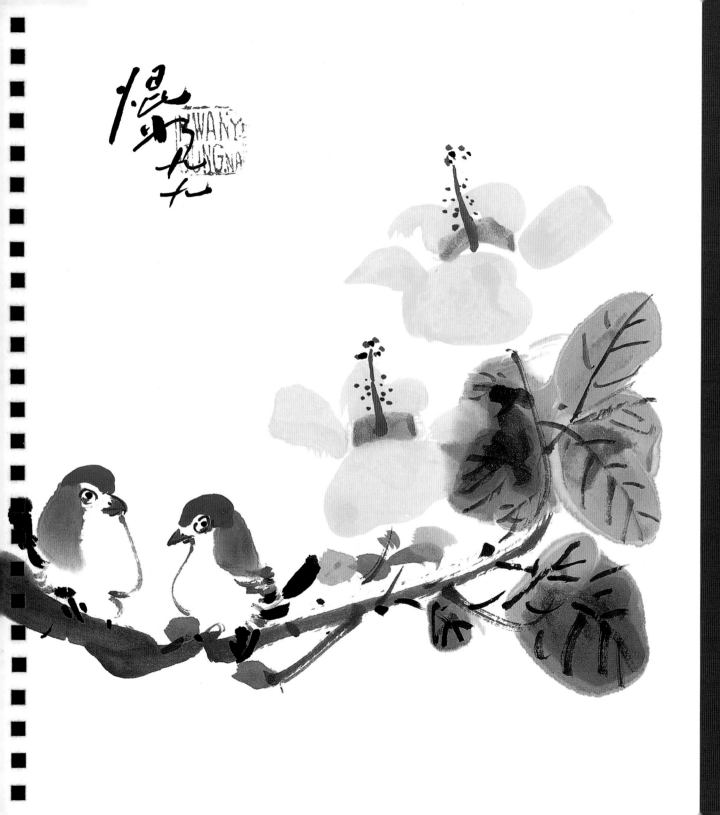

YELLOW HIBISCUS AND BIRDS
Acrylic
10" x 10" (25cm x 25cm)

PEONY FLOWERS

In China, the peony is associated with wealth and is the official flower of prosperity. It is a favorite subject to paint for many artists. A peony painting is an ideal gift for well-wishing and is a very salable item. The peony flower has many various colors. One may choose from colors that run from yellow to red to purple. Special brushwork is required to depict the flower. Working inward from the outside ramp of the flower to the center, many dipping, plunging and dotting strokes are required.

STEP 1 | THE OUTSIDE RAMP

Mix watercolor with lots of water and store it in a dish or bowl. Soak the brush with the lowest value of color. Paint plunging and dipping strokes to form a half-moon-shaped ring curving upward like the outside ramp of the peony flower.

STEP 2 | THE MIDDLE PETALS

Add more watercolor pigment to the bowl to create a higher-value mixture. Repeat the action on the top of the previous ring to form a smaller ring toward the top.

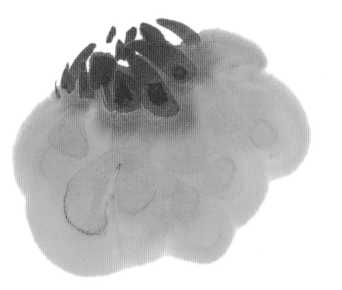

STEP 3 | THE TOP RING

Add even more watercolor to the same bowl to create a watercolor solution with full-value consistency. Soak the brush with the solution and repeat the process to form an even smaller ring. When the dipping reaches the top of the flower, stop. If the initial pigment applied is pink, it should end as a deep red color at the top.

STEP 4 | THE INK DOTS

Dry the brush and immediately wet it with very dark ink. Place ink dots randomly on top of the flower petals.

STEP 5 | ONE LEAF

Paint the leaves similarly to the flower. For each leaf, mix diluted ink with green or blue watercolor. Soak the brush with the colored ink mixture. Start from the bottom of the peony flower and paint two different sizes of soggy strokes. One should overlap the other to form one leaf; the top one piggybacks the bottom one. Make one longer than the other and end with a curved point going downward.

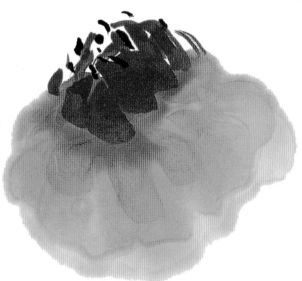

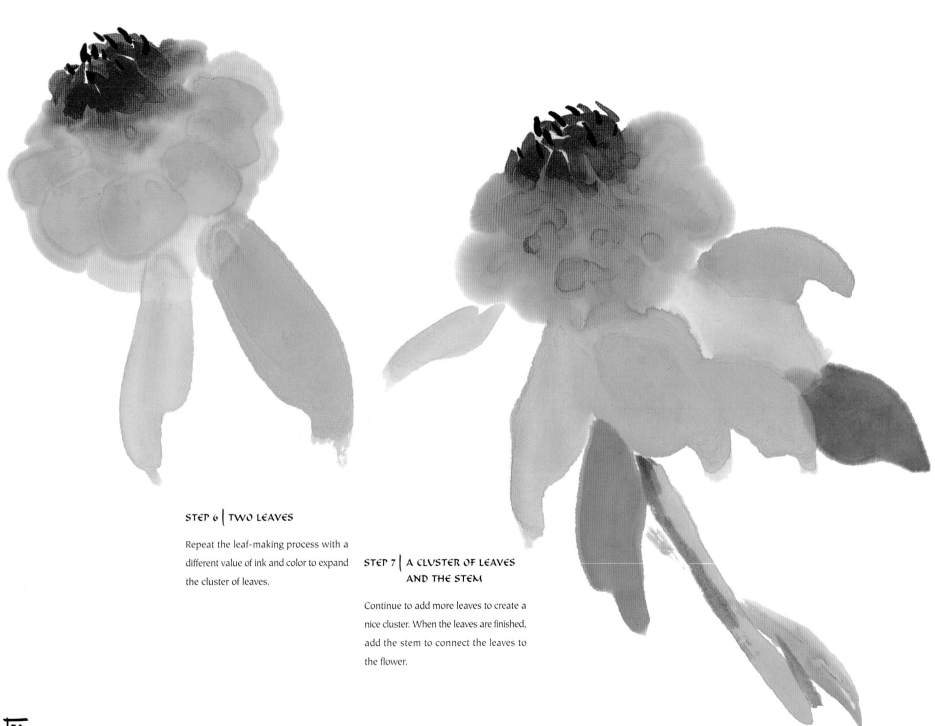

STEP 6 | TWO LEAVES

Repeat the leaf-making process with a different value of ink and color to expand the cluster of leaves.

STEP 7 | A CLUSTER OF LEAVES AND THE STEM

Continue to add more leaves to create a nice cluster. When the leaves are finished, add the stem to connect the leaves to the flower.

STEP 8 | THE VEINS AND TEXTURE

Outline the veins of the leaves with black ink. By doing so, the leaves will appear to be stronger and heavier and the flower petals will appear to be soft and tender in comparison.

PEONY
Watercolor and ink
9" x 12" (23cm x 30cm)

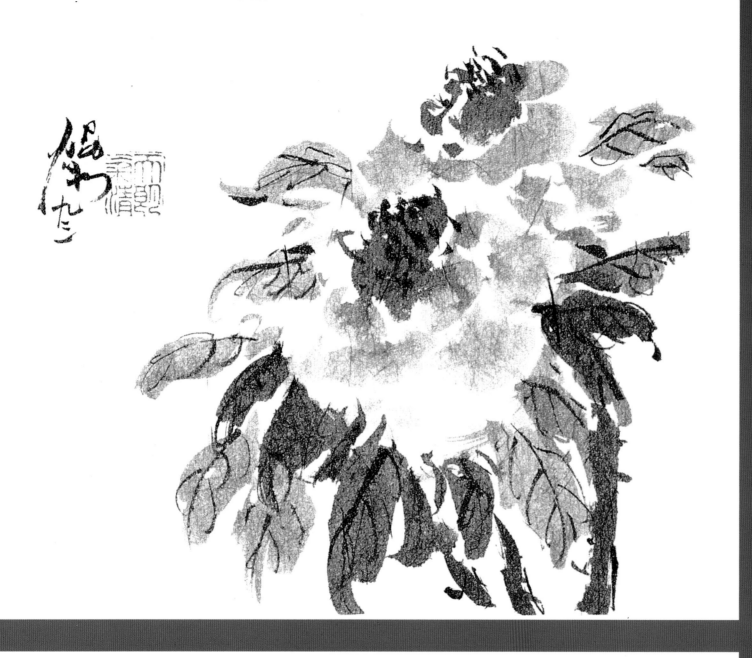

PEONY NO. 2
Ink
8" x 10" (20cm x 25cm)

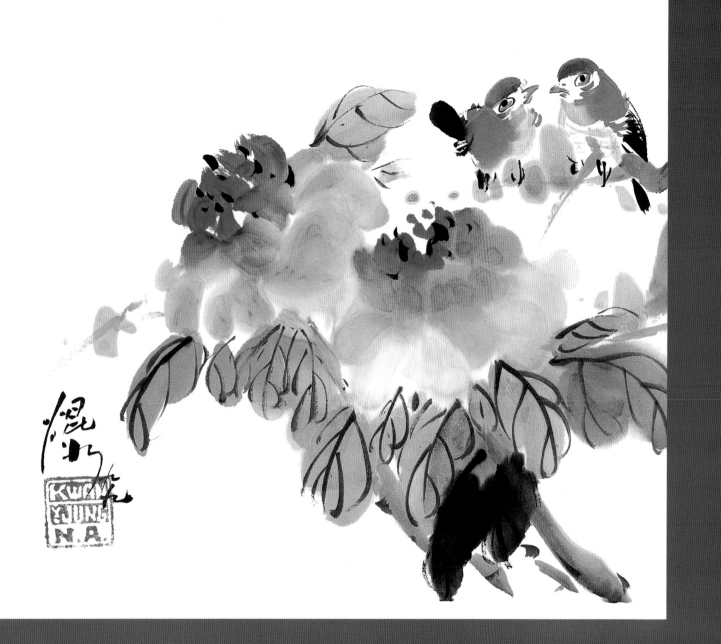

GRAPES AND GRAPEVINES

The grapevine has long, slender curved stems. In order to draw the grapevine, twisting and turning motions of the brush are required. Sometimes rolling and circling strokes are necessary to express the tender shoots searching in the air. The types of brushwork requiring twisting and turning motions are called grass style in Chinese character writing, a good example of writing characters and painting pictures that are very similar.

The calligraphy for the vine stems and the abstract rendering of the leaves are two essential parts of this grapevine painting. The leaves are woven and connected by the vine stems. Grapes are added under the leaves as the center of interest. The leaves will be painted blue, the grapes will be painted red and the grapevine will be painted black. The morning glory and the lotus flower are painted in a similar fashion using grass-style brushwork and a weaving method to pull all the elements together.

RECORDING THE BRUSHWORK

After each brushstroke is completed the painting will register the motions and the speeds of the brush. The line that represents the grapevine shows the history of the brushwork. There are moments of fast-sweeping motions, moments of hesitation in thought, moments of slow turning, etc. There is brushwork of breaks, reconnections, curls and crossroads. All these strokes are made to connect or to complete the weaving of the leaves. Triangles and forks are formed when the strokes overlay. Avoid strokes forming a cross or parallel lines. Dots are often added along the twisting and turning strokes.

STEP 1 | THE MIDDLE-VALUE LEAVES

Mix a blue color with small amounts of ink in a dish. Soak the brush with the ink and color mixture. Start with a middle-value mixture and make three blunt strokes together to form an arrowhead-shaped grape leaf.

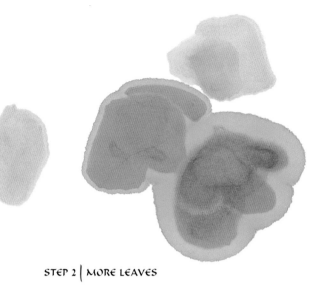

STEP 2 | MORE LEAVES

Reload the brush with a higher or lower value of the mixture. Draw leaves here and there following the theory of concentration and dispersion as mentioned on page 14. In one area, group many leaves close together so that they overlapping each other.

Away from the leaf cluster, paint some single leaves scattered and dissipated. Use the lightest value of color to draw leaves farther in the background. Each time use strokes of different sizes and values.

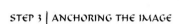

STEP 3 | ANCHORING THE IMAGE

Apply heavy ink to the brush and make a few more leaves at the edge of the leaf cluster.

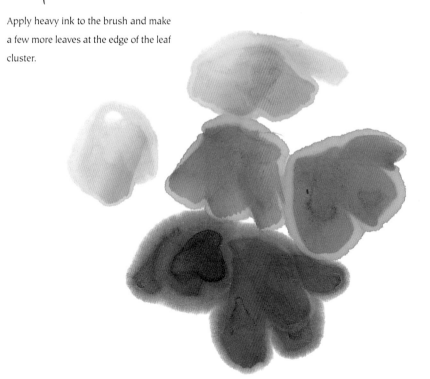

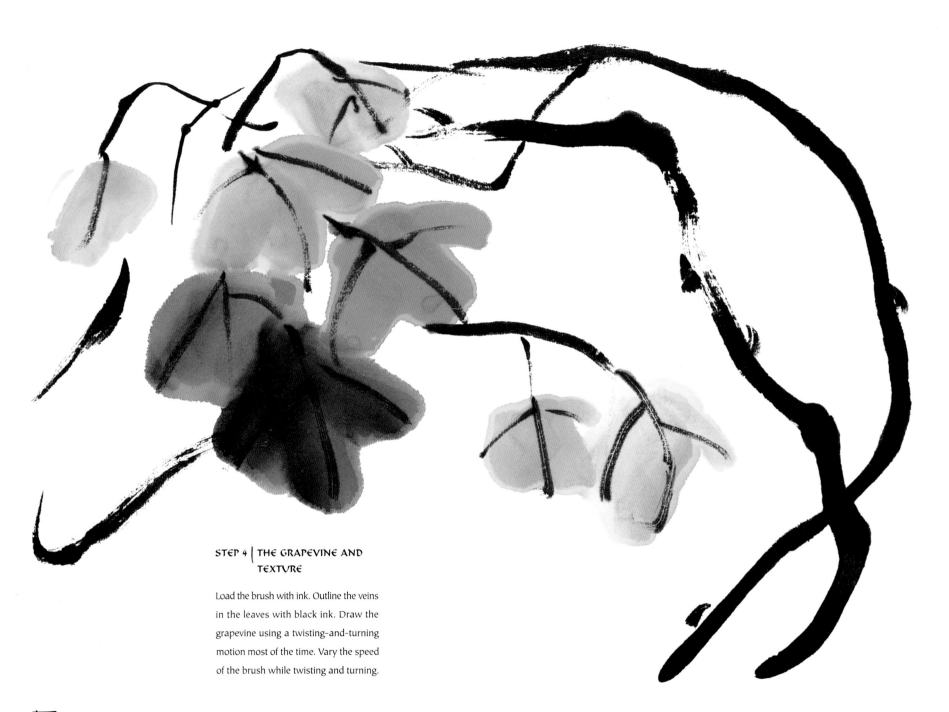

STEP 4 | THE GRAPEVINE AND TEXTURE

Load the brush with ink. Outline the veins in the leaves with black ink. Draw the grapevine using a twisting-and-turning motion most of the time. Vary the speed of the brush while twisting and turning.

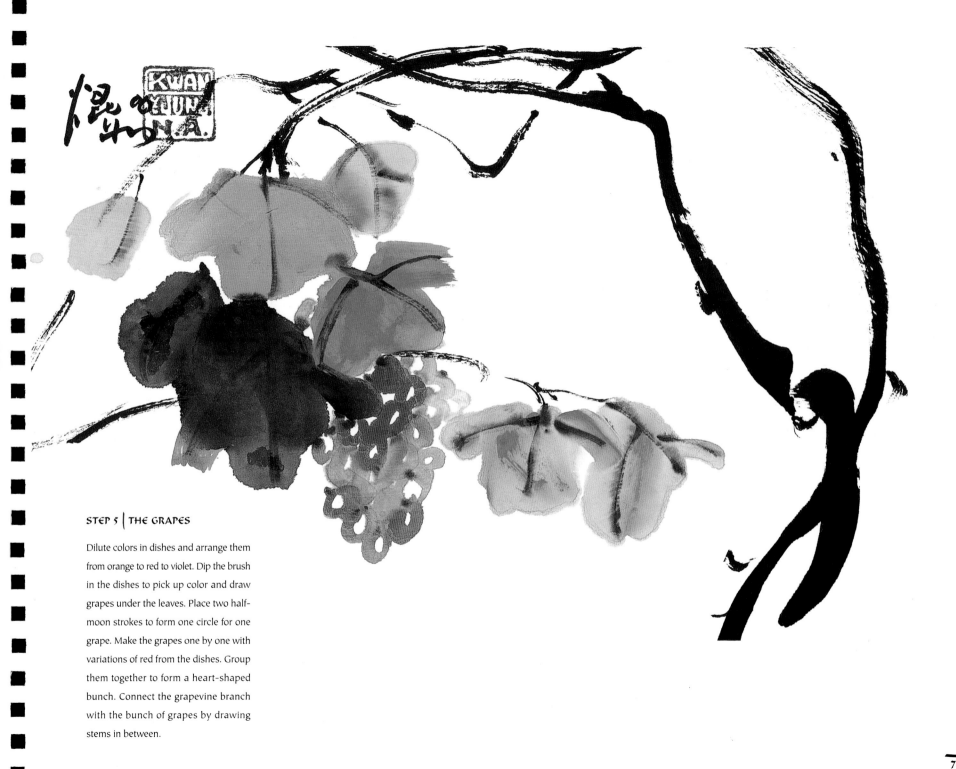

STEP 5 | THE GRAPES

Dilute colors in dishes and arrange them from orange to red to violet. Dip the brush in the dishes to pick up color and draw grapes under the leaves. Place two half-moon strokes to form one circle for one grape. Make the grapes one by one with variations of red from the dishes. Group them together to form a heart-shaped bunch. Connect the grapevine branch with the bunch of grapes by drawing stems in between.

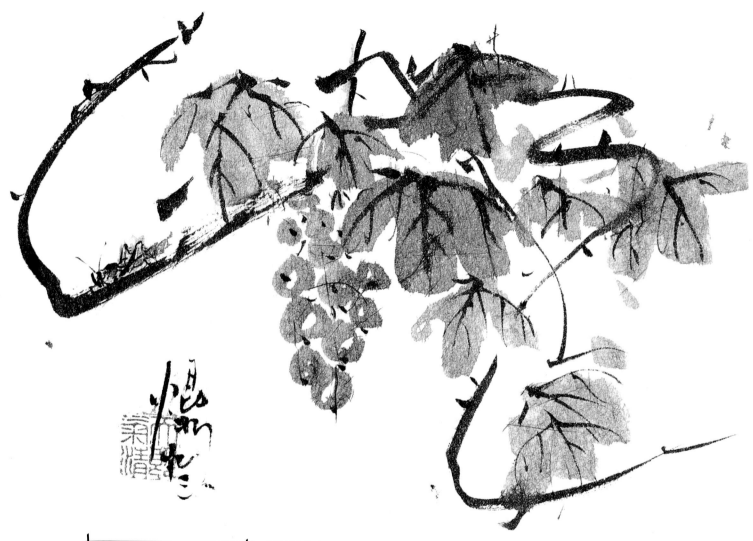

INK

Ink is the strongest color in a brush-work painting. Ink enforces, highlights, emphasizes and strengthens the subjects we paint.

GRAPE NO. 1
Ink
8" x 10" (20cm x 25cm)

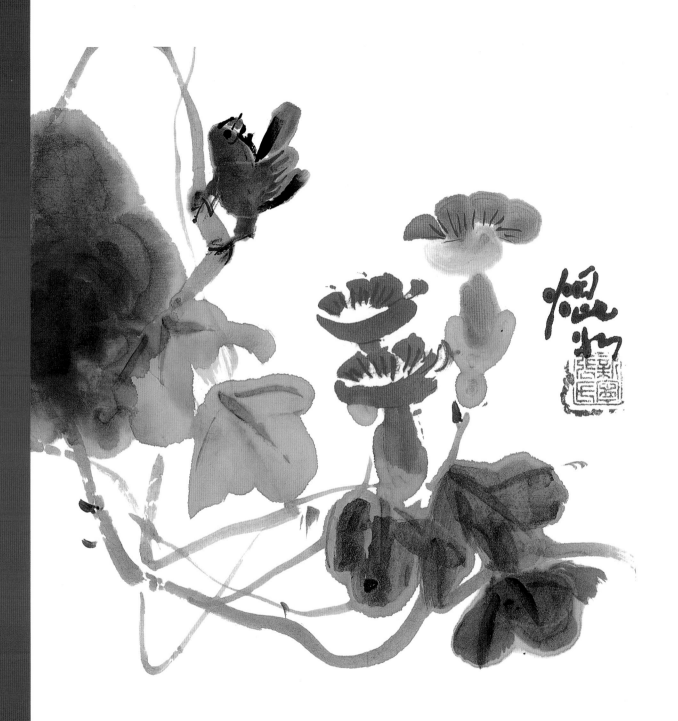

MORNING GLORY NO. 1
Watercolor
10" x 10" (25cm x 25cm)

PANDA

The panda in black and white can be a sensational subject to paint. Only water and ink are required to do this painting—it is pure calligraphy. Here is how the simple and powerful sumi-E is done. Two tones of ink are required to paint the panda. The light-value ink is for outlining the facial contour, head and the body of the panda. The heavy black ink is used for the strokes that depict the eyes, the nose and the legs. In every aspect, the panda has the distinctive characteristic of a round ball. To outline, make many curly lines around the panda's face and body.

STEP 1 | THE EYES AND NOSE

Before outlining the face, two eyes must first be positioned, followed by the nose. Paint the eyes using a pressing stroke and the tip of the brush loaded with heavy black ink. Use the same brush to paint the nose as a tilting dot. The strokes for the eyes and the stroke for the nose form a triangle.

STEP 2 | THE BRIDGE OF THE NOSE AND THE MOUTH

Outline the bridge of the nose and the mouth along the triangle of the eye and nose. Make two short, curved strokes tilting upward.

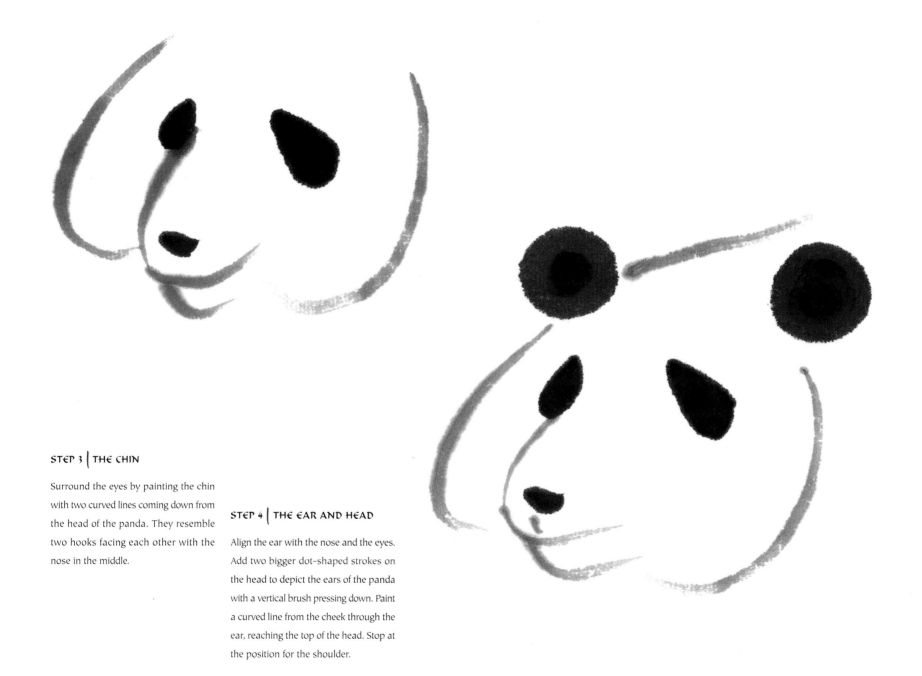

STEP 3 | THE CHIN

Surround the eyes by painting the chin with two curved lines coming down from the head of the panda. They resemble two hooks facing each other with the nose in the middle.

STEP 4 | THE EAR AND HEAD

Align the ear with the nose and the eyes. Add two bigger dot-shaped strokes on the head to depict the ears of the panda with a vertical brush pressing down. Paint a curved line from the cheek through the ear, reaching the top of the head. Stop at the position for the shoulder.

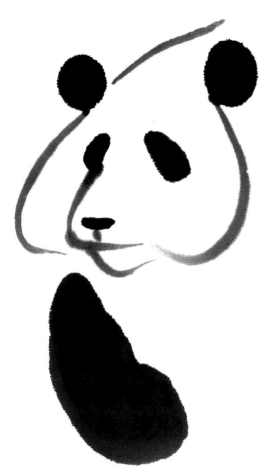

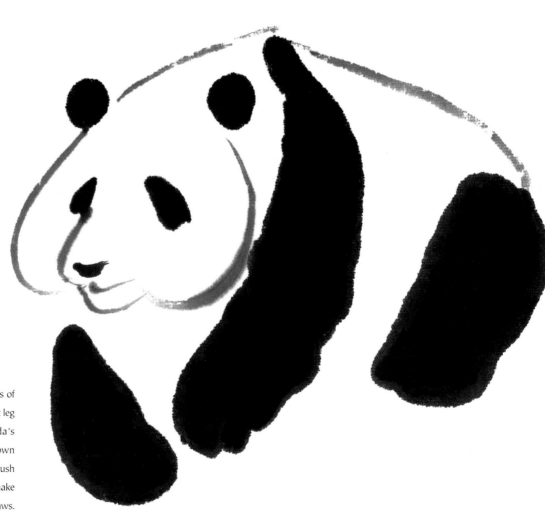

STEP 5 | THE HAND

Use a larger brush loaded with plenty of ink to paint the front leg of the panda pressing down and painting away from the head. When you end the stroke, turn the brush slightly to form the paw.

STEP 6 | THE LEGS

Soak the brush with ample amounts of heavy black ink. Draw the other front leg from the shoulder above the panda's head to the ground by pressing down really hard on the paper. When the brush reaches the ground of the painting, make an inward turn and form the front paws. Paint the rear and the back legs of the panda using the larger brush.

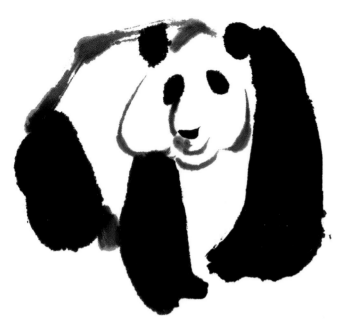

VARIATIONS OF THE PANDA

If you decide to paint a sitting panda, the position of the back legs and feet should be placed under the front legs. If you want the panda to walk or lie down, place the back leg in the back of the panda. Finally, connect all the parts with inward curving lines.

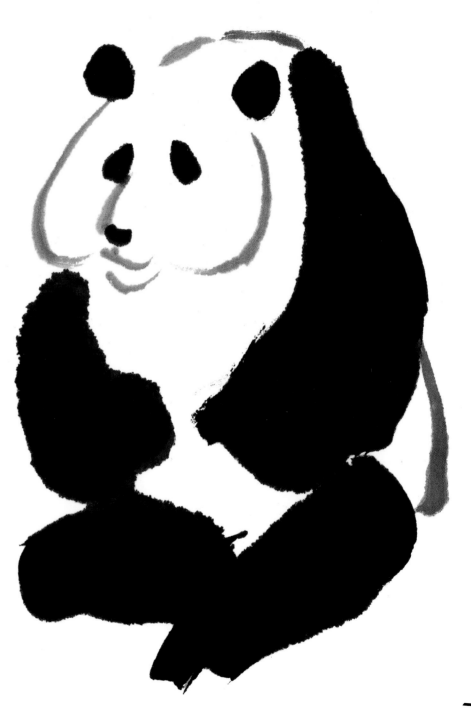

83

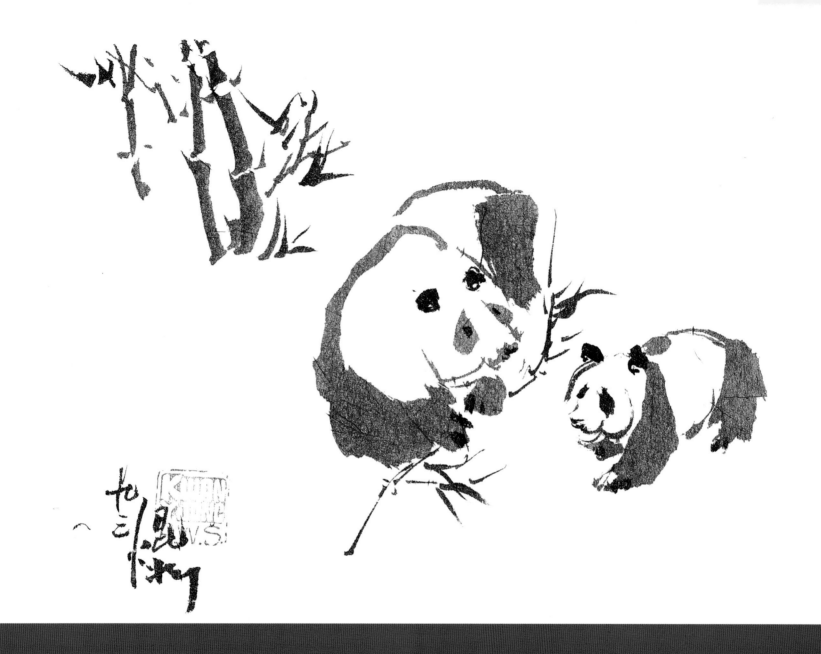

MOTHER AND CHILD
Ink
8" x 10" (20cm x 25cm)

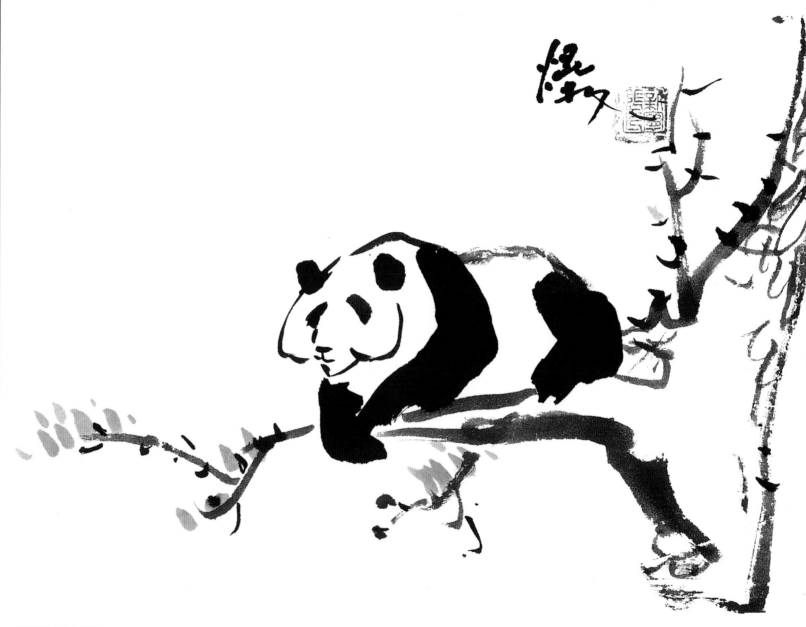

PANDA ON A TREE
Ink
11" x 15" (28cm x 38cm)

HORSE

To create a horse painting, we will use the left and right strokes used to form the tree and the brushwork used for the small bamboo branches. In fact, these two kinds of brushwork are essential for the construction of this subject.

STEP 1 | THE NECK

The first stroke will be the neck of the horse. Make a sideways blunt stroke, striking down from the left to the right. This neck stroke reaches the chest bone of the horse and determines the direction the horse is facing.

STEP 2 | THE CHEST

Work inward from the sides of the horse's chest. Make left and then right strokes toward the center to form the chest of the horse.

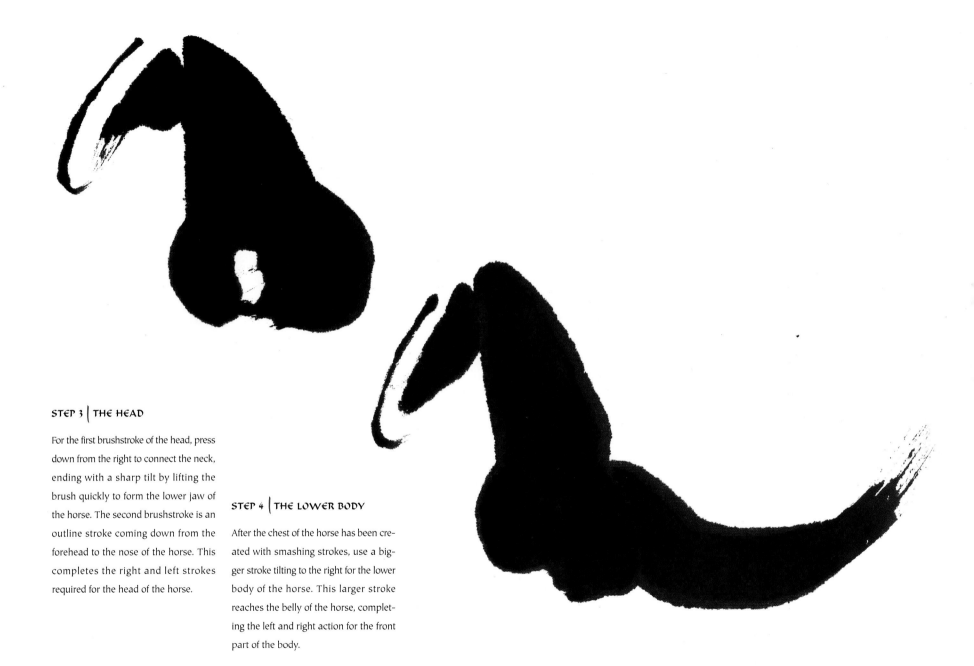

STEP 3 | THE HEAD

For the first brushstroke of the head, press down from the right to connect the neck, ending with a sharp tilt by lifting the brush quickly to form the lower jaw of the horse. The second brushstroke is an outline stroke coming down from the forehead to the nose of the horse. This completes the right and left strokes required for the head of the horse.

STEP 4 | THE LOWER BODY

After the chest of the horse has been created with smashing strokes, use a bigger stroke tilting to the right for the lower body of the horse. This larger stroke reaches the belly of the horse, completing the left and right action for the front part of the body.

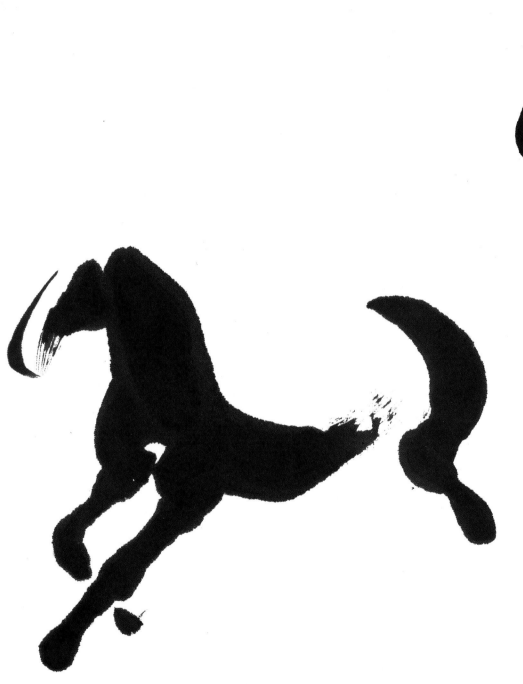

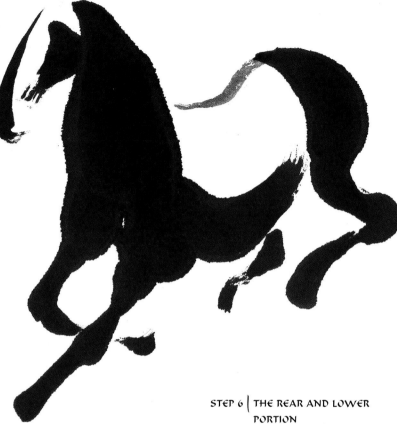

STEP 5 | THE LEGS

Apply the left and right strokes to form the shoulder and front legs on both sides of the chest. Follow the front leg strokes and make small bamboo branch strokes to represent the lower portion of the front legs. Apply the left and right strokes to the rear end of the horse. Paint the hip with a pressing-down, curly stroke to the left. With the same brush, continue from the hip and make a curved stroke down to the right, finishing the rear end and the thigh.

STEP 6 | THE REAR AND LOWER PORTION

Follow the stroke for the thigh and make a small bamboo branch stroke straight down for the lower portion of the leg and end with a pause. Add in the line for the back. All of these actions use the combinations of alternate strokes performed in left and right succession.

STEP 7 | THE HOOFS, MANE, BACK, TAIL, EARS, MOUTH AND NOSE

With all the major features of the horse rendered, the other parts, such as the hoofs, mane, back, tail, ears, mouth and nose, can be outlined and added using lines of different-valued ink.

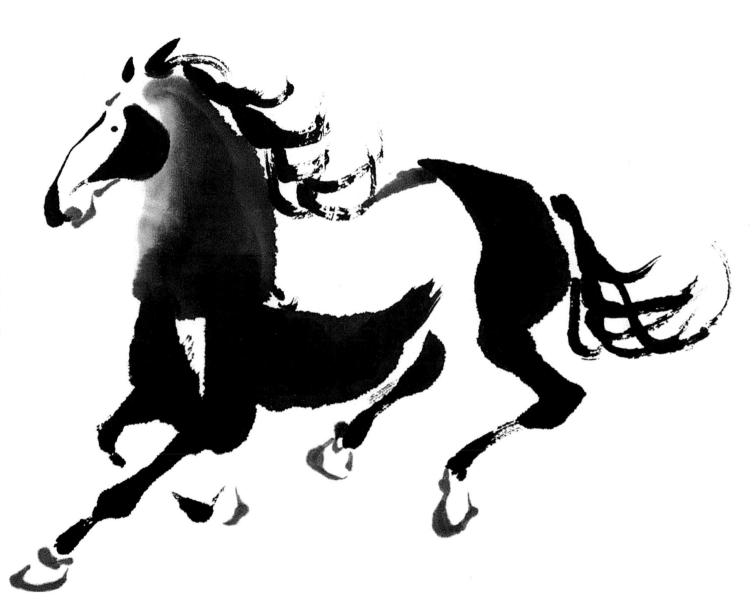

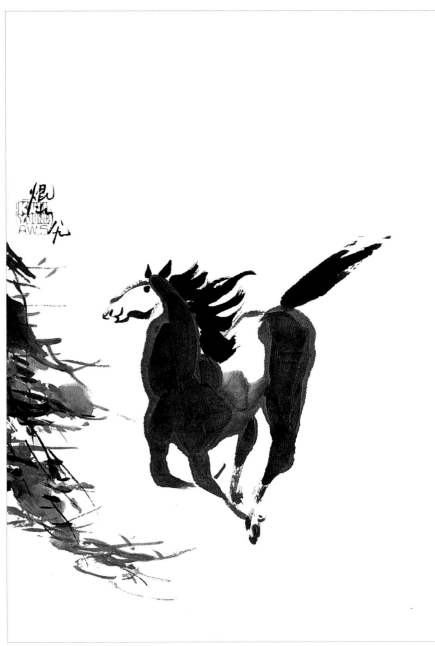

RUNNING
Watercolor and ink
18" x 13" (46cm x 33cm)

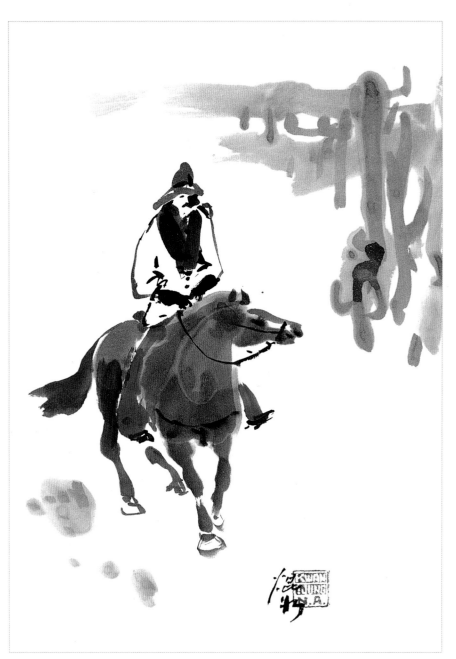

HORSE AND RIDER
Watercolor
17" x 13" (43cm x 33cm)

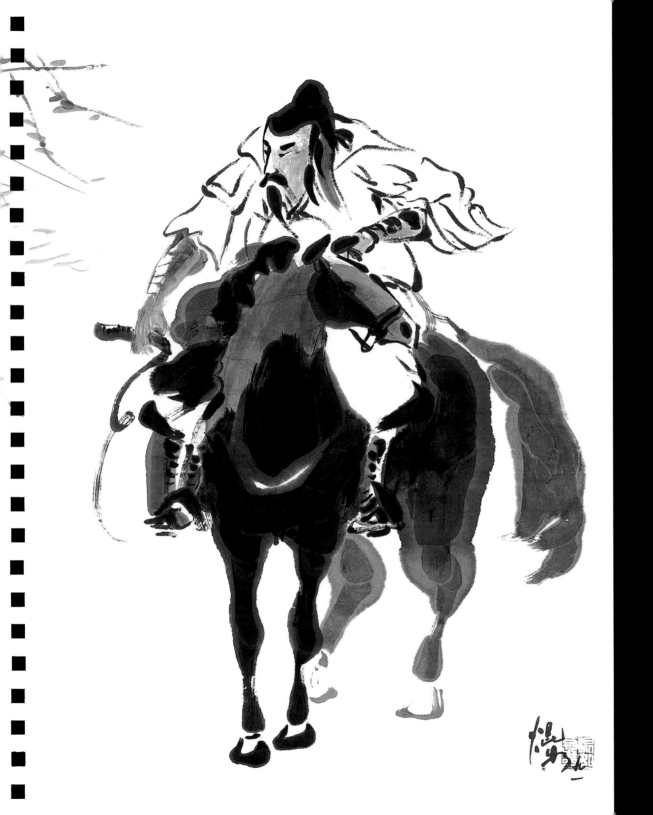

ANCIENT RIDER
Ink
25" x 19" (64cm x 48cm)

WET PAINT

Watercolor painting is best when it is wet, not dry. Use heavier pigments, higher values and stronger color to prevent fading after the painting is dry. Maintaining the liquidity of the painting—the characteristic wetness—is not easy; however, the natural ability of the Xian paper to absorb and retain watermarks can help us accomplish this quality. Select the best paper for your painting!

MANDARIN DUCKS

The distinct features of birds are the bill and tail. The head and the tail of the bird are always rendered with the strongest color or deepest value in comparison to other parts of the bird. These two major features must be established strongly in order to bring about the presence of the bird in a painting, especially when many other elements are involved. When painting the bird, the starting point can be the head or the chest. After painting the head or body, the pose of the bird is painted followed by the tail. The feet are completed last.

The Mandarin duck can be depicted in the same manner. The body of the duck usually resembles a rubber raft; it is round on both ends. The tail of the duck has a tendency to tilt up. The neck settles firmly on the top of the chest.

The male and female Mandarin ducks differ in shape and color. The male has streamlined golden feathers flowing down from the head and the protrusive golden wings. It has a backward flow of black hairlike feathers sliding down from the top of its head. The head and neck of the male Mandarin duck has the appearance of a triangle. The bill is parallel to the body for both of them. The male has multicolored feathers while the female has only earth-tone feathers.

A pair of Mandarin ducks serve as playing partners in a pond. They symbolize love when they are paired in one place. Perhaps they are playing or relaxing in the water. Pay attention to all the different kinds of brushstrokes that have been used to paint a pair of Mandarin ducks.

THE MALE MANDARIN DUCK

The following demonstration shows you how to paint the colorful male Mandarin duck.

STEP 2 | THE EYE

Place an eye dot in the center position of the forehead with the same brush.

STEP 1 | THE HEAD

Begin with the backward-flowing black hair. Load the brush with black ink. Draw the forehead of the bird. The line goes upward then makes a 90-degree curve, pressing downward to form the sloped feathers.

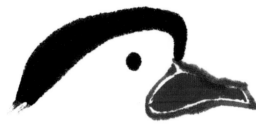

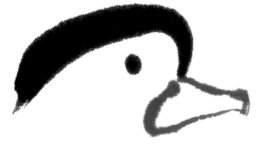

STEP 5 | THE S-SHAPED FEATHERS

Create a triangle shape: The baseline of the triangle is formed under the bird's head by connecting the eye socket and the feathers of the duck. This horizontal base line is formed by drawing a long letter "S" with a brown color starting at the eye socket and moving backward to the end of the backward stroke.

STEP 4 | FILL IN COLOR

Clean the brush with pure water again. Load the brush with bright red and fill in the duck's bill.

STEP 3 | THE DUCK BILL

Clean the brush in the water bowl. Dip the brush in the dish of lighter-value ink. Wipe off any excess water with a paper towel. With the brush hair almost dry, start from the beginning point of the forehead stroke and draw the cone-shaped bill of the duck.

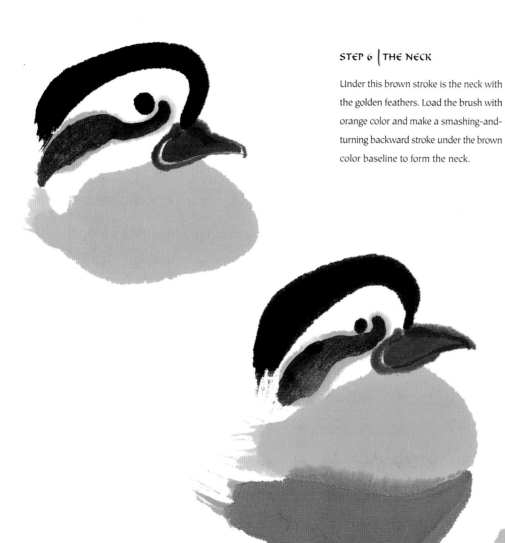

STEP 6 | THE NECK

Under this brown stroke is the neck with the golden feathers. Load the brush with orange color and make a smashing-and-turning backward stroke under the brown color baseline to form the neck.

STEP 7 | THE CHEST

The chest of the Mandarin duck is a brownish purple color. Mix purple with some brown in a dish and load the brush with plenty of this color. Make a downward stroke under the neck, connecting the neck to the chest by turning the brush and moving in the direction of the tail. Stop abruptly.

STEP 8 | THE BODY AND WINGS

The colors covering the body of the Mandarin duck are black, blue and white, arranged from the top of the back to the bottom of the body. Before painting the body parts, draw the golden wings. Clean the brush and load it with orange color. Use the slanting brushstroke to strike upward and create a rounded but sharp-ended wing. When the positions of the wings are settled, connect all the parts with a blue stroke.

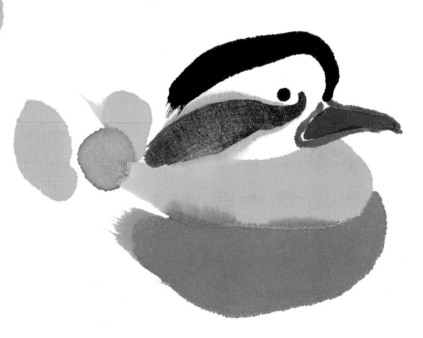

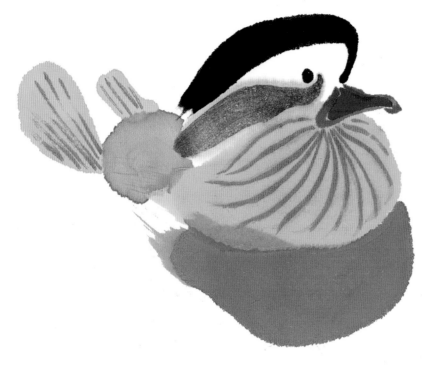

STEP 9 | THE RED STRINGS

Thoroughly clean the brush and pick up some red color with the tip of the brush; wipe off any excess color. Draw short and long lines following the flow of the feathers down to the chest. Draw fine parallel lines on the plane of the sharp-ended wing. All the red lines should end within the orange color area.

STEP 10 | THE BLACK STRIPES

Clean the brush with water and dry it using a paper towel. Dip the brush in heavy black ink and draw three stripes next to the chest.

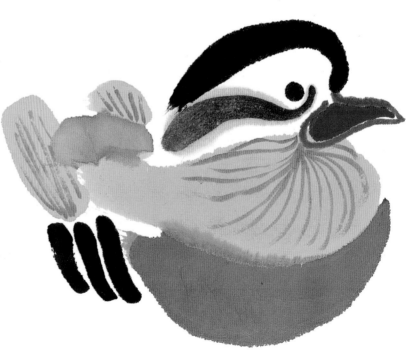

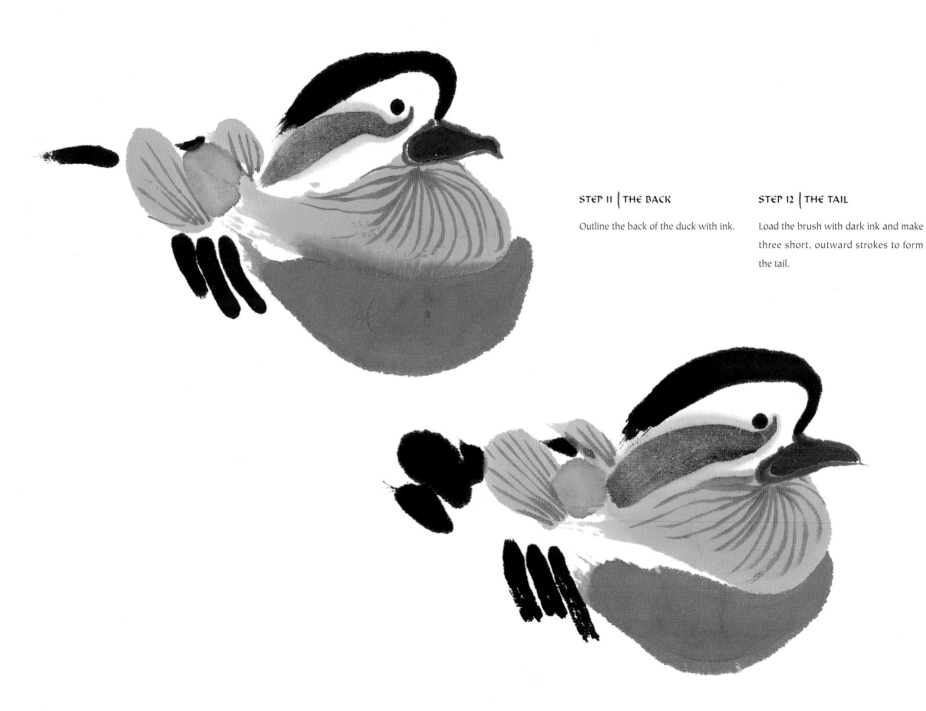

STEP 11 | THE BACK

Outline the back of the duck with ink.

STEP 12 | THE TAIL

Load the brush with dark ink and make three short, outward strokes to form the tail.

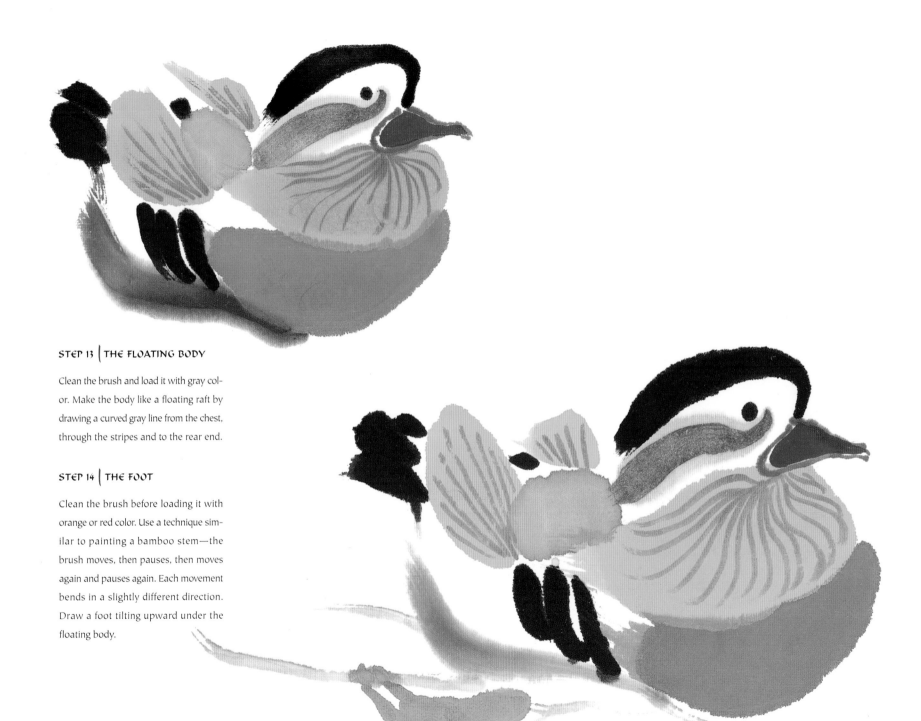

STEP 13 | THE FLOATING BODY

Clean the brush and load it with gray color. Make the body like a floating raft by drawing a curved gray line from the chest, through the stripes and to the rear end.

STEP 14 | THE FOOT

Clean the brush before loading it with orange or red color. Use a technique similar to painting a bamboo stem—the brush moves, then pauses, then moves again and pauses again. Each movement bends in a slightly different direction. Draw a foot tilting upward under the floating body.

THE FEMALE
MANDARIN DUCK

The female Mandarin duck has less colorful feathers and a more simple body compared to the male. The body color of a female Mandarin duck consists of only black ink and earthy brownish colors.

STEP 2 | THE BODY

Load the brush with Burnt Umber and make a swift side stroke from the neck toward the tail. Outline the back with the same brush.

STEP 1 | THE NECK

Dilute Burnt Umber with water and store it in a dish. Load the brush with the diluted solution. Press the brush all the way down to form the neck.

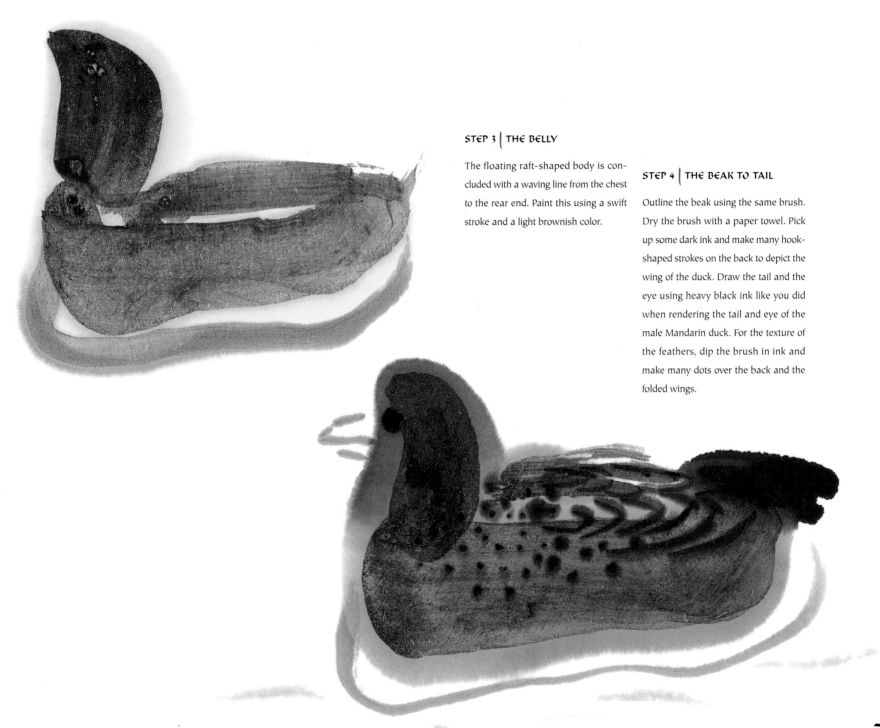

STEP 3 | THE BELLY

The floating raft-shaped body is concluded with a waving line from the chest to the rear end. Paint this using a swift stroke and a light brownish color.

STEP 4 | THE BEAK TO TAIL

Outline the beak using the same brush. Dry the brush with a paper towel. Pick up some dark ink and make many hook-shaped strokes on the back to depict the wing of the duck. Draw the tail and the eye using heavy black ink like you did when rendering the tail and eye of the male Mandarin duck. For the texture of the feathers, dip the brush in ink and make many dots over the back and the folded wings.

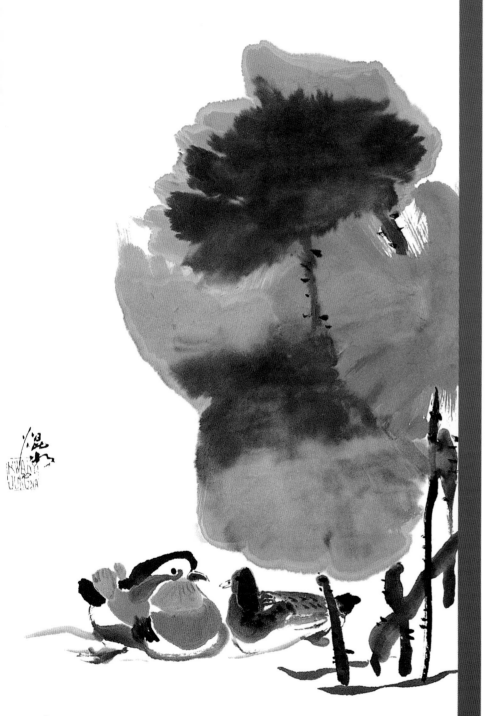

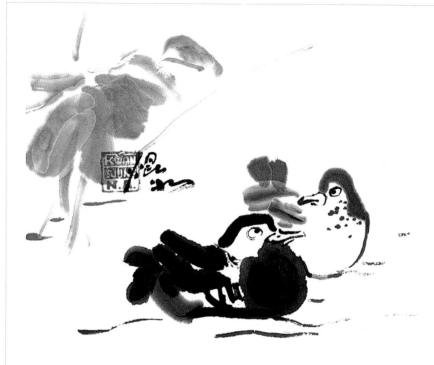

MANDARIN DUCK NO. 1
Ink
10" x 11" (25cm x 28cm)

MANDARIN DUCK NO. 2
Acrylic
19" x 14" (48cm x 36cm)

MANDARIN DUCK NO. 3
Watercolor
10" x 12" (25cm x 30cm)

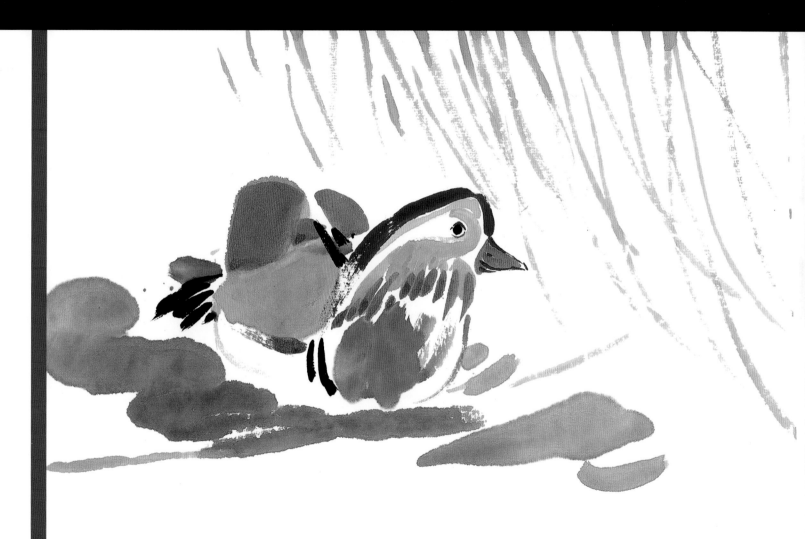

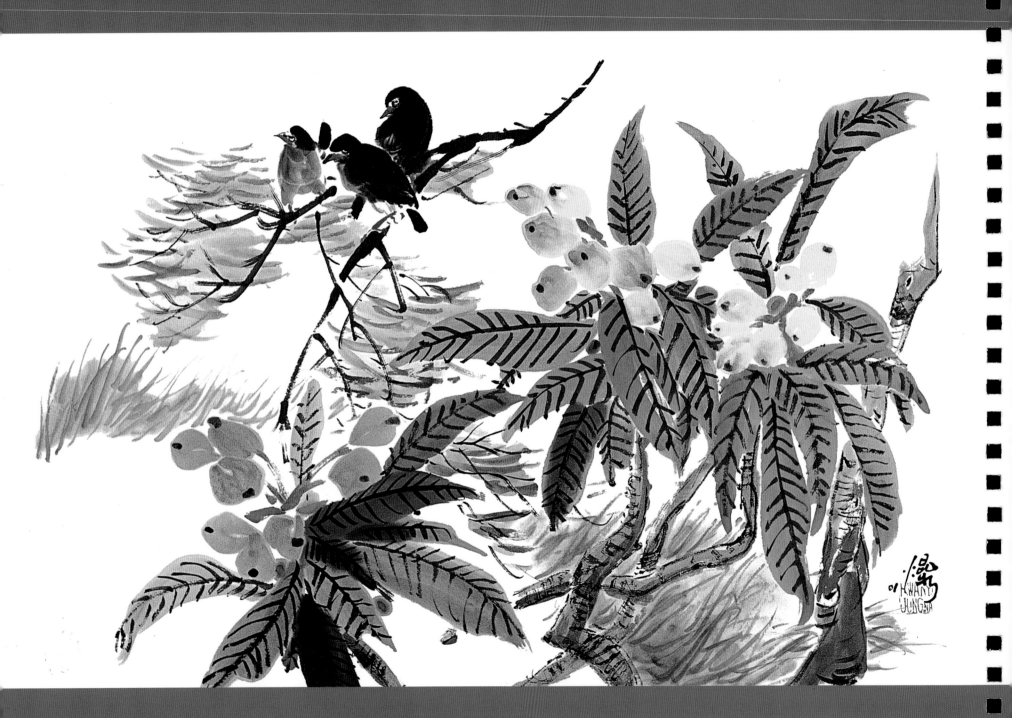

A SIMPLE CRITIQUE
BY COMPARISON 3

In the world of sumi-E (ink painting), everything is painted in black and white; no colors are involved. Ink is supreme in sumi-E. The artist paints what he or she feels, but not much of what he or she sees. *What* we feel about the art we have created is more important than the actual facts of the subject matter. *How* we feel about the subject matter is what we are trying to portray in our paintings. How we feel about it is also used to measure the quality of our painting. This standard can be applied to sumi-E or other brush paintings with color.

In the dictionary, the word *feel* is defined as perception through the sense of touch, or to experience a physical sensation. So, it is a physical thing we are talking about. Subject matter in a painting can be felt as heavy, strong, rich, husky, thick, flimsy or weak, poor, sheer and thin. They can also be wet, moist, juicy, shiny, dry or dull. There are terms of comparison like whole to part; unity to fragment; completeness to debris; bulk to crumb; mass to scatter; clean to dirty; solid against superficial; smooth against sharp; and soft against harsh. These terms of comparison determine the painting's direction. The measurement can be made by putting the finished artwork in front of our eyes and, through our imagination, in our hands. Once we imagine it in our hands, we can feel it and form a judgment.

LOQUATS ARE RIPE
Acrylic
17" x 26" (43cm x 66cm)

THE BIRD'S EYE VIEW
VS. THE HORIZONTAL VIEW

Picture this: You are making a painting while standing on a balcony, looking down upon a courtyard and garden below. You see the entire view in front of you, both near and far. This is the bird's eye view. Now picture this: You are making a painting while sitting in a chair, looking at the objects on a table. You can view only what is in front of you—you cannot see what is beyond the table or behind you. This is the horizontal view. Both paintings, *Outdoor* and *Indoor,* are balanced by the breakaway signature and seal, because the rose and lichee are the center of interest.

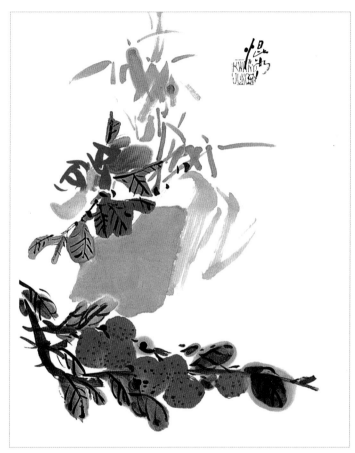

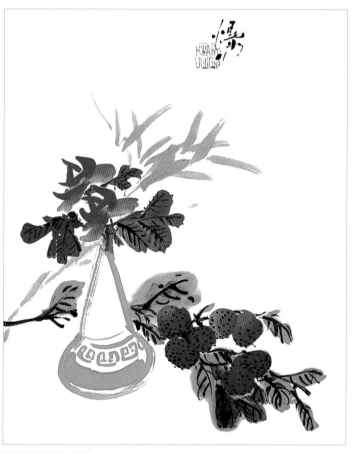

BIRD'S EYE VIEW

This point of view allows you to paint all the subject matter from above. The tree branch is painted first, followed by the leaves of the lichee tree. An intense value of red is used to paint the lichee fruit. The vertical brush presses down in a circling motion, rounding out the fruit. The bumpy husk texture of the lichee fruit skin is created using a brush dried with a paper towel, wet with heavy dark ink, to make many small dots over the fruit. The rock

behind the lichee branch is painted with a larger sheep hair brush. The roses are painted with a full high-value red, beginning at the center of the flower and working toward the rim with a decreasing value of red. Lastly, the bamboo behind the rock is added.

OUTDOOR
Watercolor
17" x 13" (43cm x 33cm)

HORIZONTAL VIEW

The rose is painted in the same manner as in Outdoor, *followed by the vase under the roses and the lichee. Lastly, the bamboo is added as the background of the painting. The elevated horizon of the painting is frequently used to carry the subject matter in different levels.*

INDOOR
Watercolor
17" x 13" (43cm x 33cm)

AIRY VS. STUFFY

Do not overcrowd the space with too many subjects in a painting. When composing a painting, consider the amount of subject matter represented. The viewer will pay close attention to the subject matter. Less subject matter is more relaxing for the viewer; less is better. Sometimes there can be too much for the eye to see in one painting.

AIRY

The five characters, four sentences poem is written to describe, accompany and ask a question about the subject matter, which in this case is the squash. The painting is designed so that the poem only occupies part of the painting space. Here is the poem in English: "Naturally, the vines of the squash plant are there connecting the earth and the heaven. And it is so believed that the squash has the ability to search for the ancient soul in the dark. The characteristics of the vines are so strange. Is it because the southern wind is warm?"

SQUASH
Acrylic and ink
26" x 17" (66cm x 43cm)

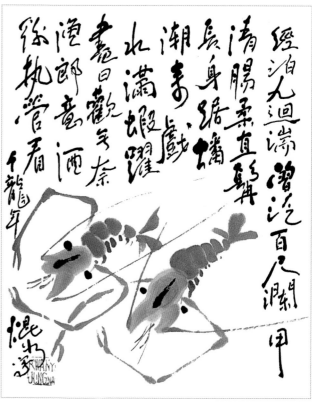

STUFFY

This five characters, eight sentences poem occupies most of the empty space in this painting. With the space fully occupied, there is no directional flow in existence. There is no need to balance the painting. The translation of the poem is: "They have made home in endless winding rivers. They have jumped over hundred-foot-high waves. They have guts which are long, clear and soft. They have long whiskers and their curved bodies are energetic like a dragon's. They can play in full tide. They can jump happily all day long. However, they cannot change the mind of that fisherman who is watching them with his bamboo stick after drinking wine."

IN THE WATER
Watercolor and ink
14" x 11" (36cm x 28cm)

FLAT VS. ROUND

The weight of an object can be delivered by how you work with the bamboo brush. The manipulation of the brush determines whether the objects in your painting are round or flat. You can create form or mass in your paintings by varying the amount of ink you use.

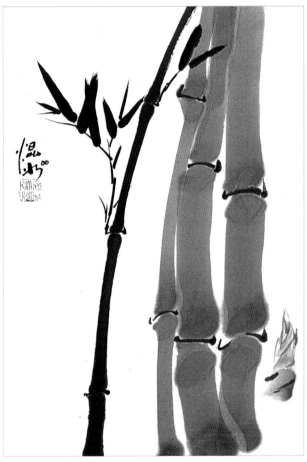

ROUND

The vertical brush creates the bamboo trunk as well as the branches and the heavy weight of the bamboo leaves. The small bamboo tree trunks are painted with a higher value of ink; the large trunks use a lighter value. The bamboo shoots and leaves are painted with full-value ink. All brushstrokes should carry plenty of water and use the three-fingers hold. The signature and seal are placed close to the bamboo leaves to complete this painting. The directional flow runs from the bamboo shoot to the bamboo leaves. The leaves are the center of interest and a join-in signature and seal are used.

VERTICAL BRUSH BAMBOO
Ink
19" x 13" (48cm x 33cm)

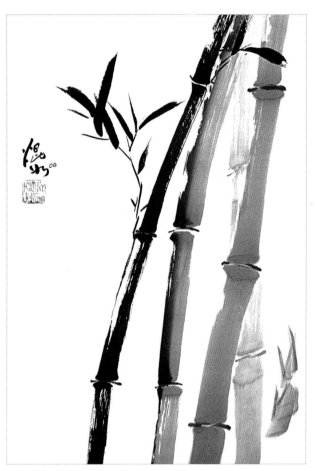

FLAT

These bamboo sticks are rounded yet thin to give them a more realistic appearance. The sheer, light leaves are created using a slanting brush. To paint the bamboo trunk with light on one side and shadow on the other side, load the brush first with a light-value ink and slightly dip the tip of the brush in a dark ink before paining. The slanting stroke is best performed using a sable brush; however, the sable brush cannot hold enough water to finish the whole bamboo trunk at one time. It is best to paint it in sections, from trunk node to trunk node.

SLANTING BRUSH BAMBOO
Ink
19" x 13" (48cm x 33cm)

MOIST VS. DRY

The texture is decided by the amount of water used. The texture is refined and smooth when the brush is wet and rough and rugged when the brush is dry. There are many variations in between the two extremes.

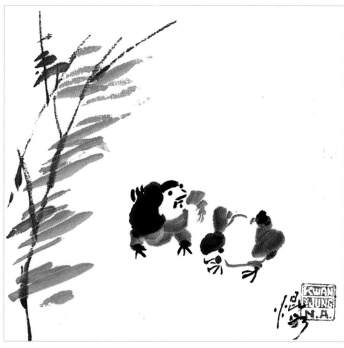

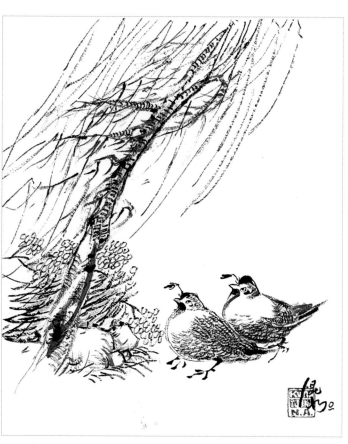

MOIST CREATES SMOOTH

To create smooth textures in your paintings, use a moist brush loaded with ample ink. First the head is painted, followed by the wings of the chicks. The bodies are then outlined, finishing with the feet. The slanting-brush technique is used to add the windy bamboo tree. The chicks are the center of interest and the signature and seal have joined in with them.

CHICKS IN WIND
Ink
10" x 11" (25cm x 28cm)

DRY CREATES ROUGH

Most of the subject matter in this painting is constructed by drawing with a dry brush. First, the brush is loaded with ink then dried with a paper towel. The slanting brushstroke is used to outline the details. The background setting is painted first, followed by the quails.

CALIFORNIA QUAILS
Ink
15" x 12" (38cm x 30cm)

STRONG VS. WEAK

The size and the value of the subject matter in a painting can make the difference between a strong and weak dramatization. It is a matter of light and dark in tone, as well as a matter of small and large brushwork. Power can be delivered by using more dark ink or stronger colors for your subject matter. We can make the small eagle big and heavy and the big mountain goats small and light.

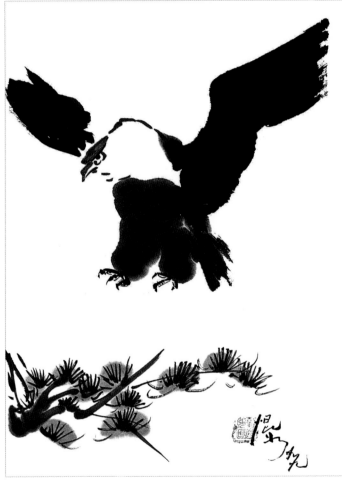

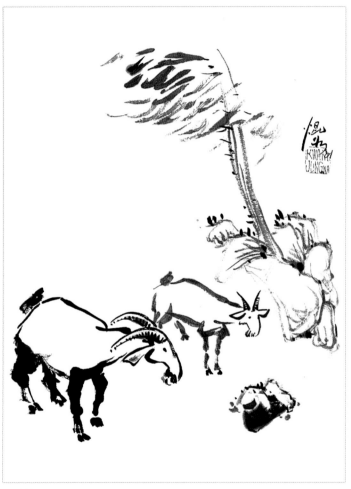

STRONG

The power of the eagle is captured in this strong painting. The dramatic contrast of light and dark, as well as the strong brushstrokes, make this a strong painting. First, the head and neck of the eagle are outlined with light ink. A bigger brush loaded with a high-value ink is then used to paint the body and the wings, followed by the legs. The pine tree is painted starting with the tree branches, leaving openings for pine needles to intersect later.

EAGLE LANDING
Ink
18" x 13" (46cm x 33cm)

WEAK

This painting is done is a manner similar to a traditional landscape painting. The lack of contrast in values and the small amount of ink create a weak painting. The surrounding scenery is completed before adding people or animals. First the rock and tree on the mountain are painted, followed by the mountain goats.

MOUNTAIN GOAT
Ink
17" x 13" (43cm x 33cm)

SOLID VS. SUPERFICIAL

A subject is considered solid when the brushwork is connected and blended together. Using enough water will bind all the strokes together. The subject appears superficial when the brushwork is disconnected and separated in the breakaway form. A steady hand and certainty in handling the brush, as well as using an adequate amount of water, helps to make the images appear to have a solid form.

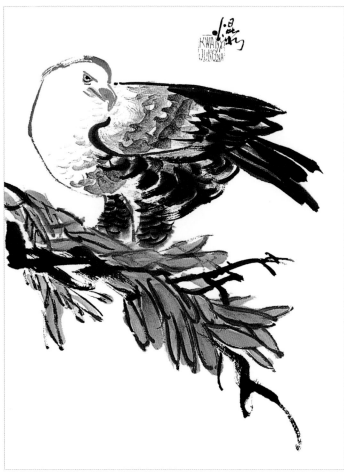

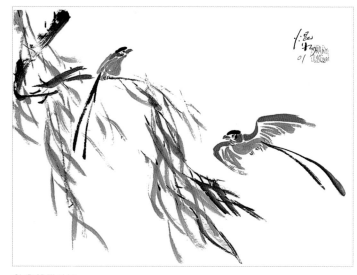

SUPERFICIAL

This composition is superficial. The strokes are disjointed and spread apart from one another, creating an open-air feeling. To create the breakaway effects, use slanting brushwork for the willow tree, tree leaves and the wings of the birds.

SHAFT-TAILED WHYDAH
Acrylic
14" x 19" (36cm x 48cm)

SOLID

The use of color gives the eagle a solid look; it connects the feathers and binds them together. Use ink to outline the eagle's head, chest, wing and tail. Use one brushstroke for each piece of feather while painting one feather connected to another. Fill in with the brown color to unify the strokes and bind all the feathers into one unit.

AFRICAN CROWNED EAGLE
Acrylic and ink
17" x 13" (43cm x 33cm)

UNIFIED VS. CHAOTIC

The directional flow of the brush-work and the placement of the subject matter have a lot to do with unifying the painting in general. To avoid a chaotic painting, the eye must be directed in one way so it follows the painting in an orderly manner. There is a hidden path in the painting for the brush to follow. Another way to unify a painting is by using similar brushwork to render all the subject matter. The artist is in control of how to depict the subject in a painting by his or her own particular style of brushwork.

UNIFIED

Only big and fat strokes are employed in this painting. All strokes for the leaves in the tree are painted pointing downward to create the same direction with a unified feeling. Using the same style of brushstroke creates unity.

UNDER THE FULL MOON
Ink
27" x 12" (69cm x 30cm)

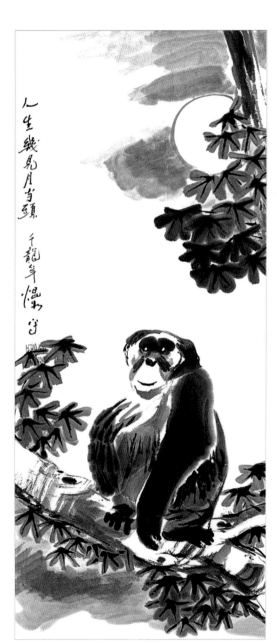

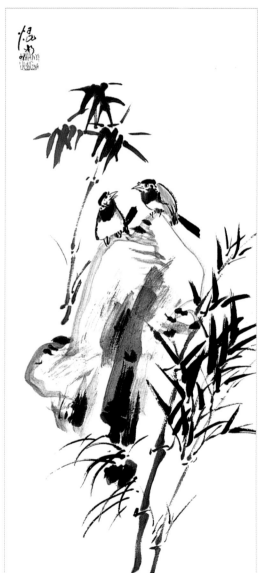

CHAOTIC

Only small and narrow strokes are used in this painting. One part of the bamboo leaves are created facing upward while the others are painted downward. Because of the different directions the leaves take, there are conflictive and disharmonious directional flows within the painting.

CHATTING ALONG
Ink
27" x 13" (69cm x 33cm)

VITALITY VS. STATIC

The death or life of a painting hangs on the variation of the brushwork. This small variation makes a big difference. Sameness is less favorable in this art. Every brushstroke has its own size, length, value, wetness, dryness, texture and color. If you can vary the brushwork when rendering the subject, you will have a painting full of vigor and life.

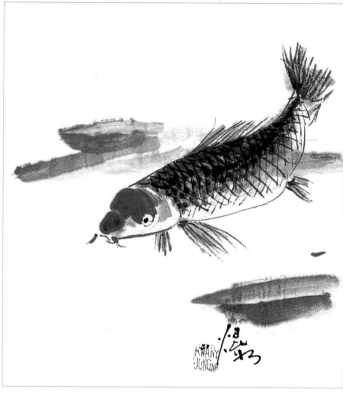

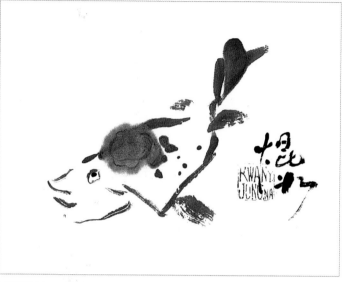

VITALITY

Various forms of brushwork are combined with different values of ink to express the fish. The variations of brushstrokes exhibit the movement of the fish.

FISH
Ink
9" x 9" (23cm x 23cm)

STATIC

With a limited variation of brushwork in the display, this painting turned to chiaroscuro (light and shadow) for help. Watercolor techniques such as charging and washing are also applied to the checkered lines that form the scales of the fish. These many variations give the painting movement.

KOI
Ink
13" x 13" (33cm x 33cm)

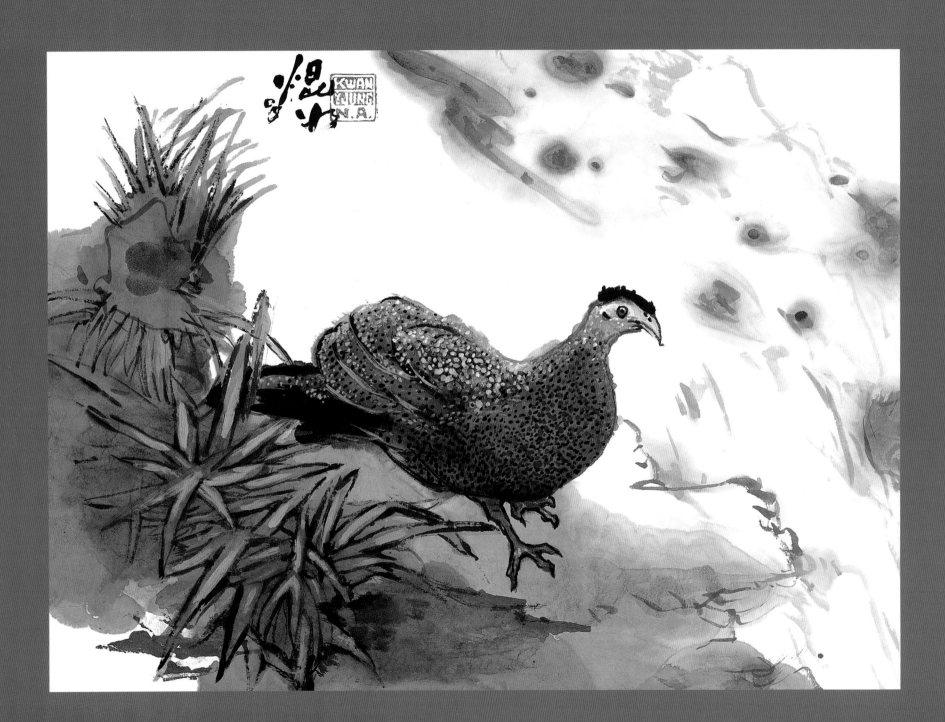

4 GALLERY

Brush painting is more closely related to Impressionism than to realistic painting. It is best expressed by the artist and brush working together. It is based solely on the imagination or memory of the painter. The scenery comes from no particular earthly place we can find and ends in a place we cannot see. Ideas come and go until they are recorded on the paper. Often, the painting only reflects the subject matter in that particular place and moment. The subject matter is just a segment that lingers in the center of the painting, surrounded by the empty white space of the paper. The whiteness of the paper provides a transitional space for the painting to fade in and out. As a rule, there is not much at the edge of a brush painting.

This fade-in and fade-out process also happens in many European paintings. One example can be found in traditional oil portrait painting. Instead of white space, a dark value is employed as the background. This is also true for some still-life paintings and other indoor subjects; the space around the subject matter fades out from the image into the dark. Landscape painting is a different matter. All the elements and details surrounding the subject matter are usually depicted accordingly. The result is quite different; the painting resembles the view from a window. The elements of the painting touch all the edges of the canvas or paper. These paintings have realistic details or impressions of all the objects depicted in the landscape. It is not surprising to see that the edge of the painting is full of elements.

Since almost all brush paintings have little to show at the edge, this helps the viewer to focus on the subject matter. This may give the viewer the impression that the subject matter is uninhibited—free of enclave and encumbrance. This enhances the vitality of the brushwork. If you avoid placing the elements around the edge as much as possible in a painting, you will produce a more authentic brush painting.

MALAY ARGUS PHEASANT
Acrylic
16" x 24" (41cm x 61cm)

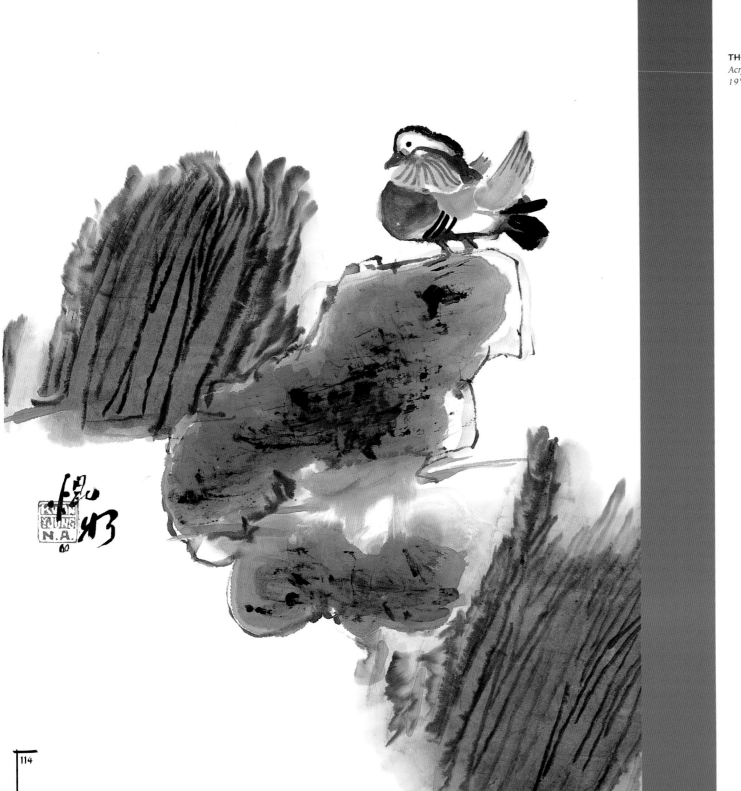

THE MALE MANDARIN DUCK
Acrylic
19" x 16" (48cm x 41cm)

THE SWIMMING WATER BUFFALO
Acrylic
14" x 25" (36cm x 64cm)

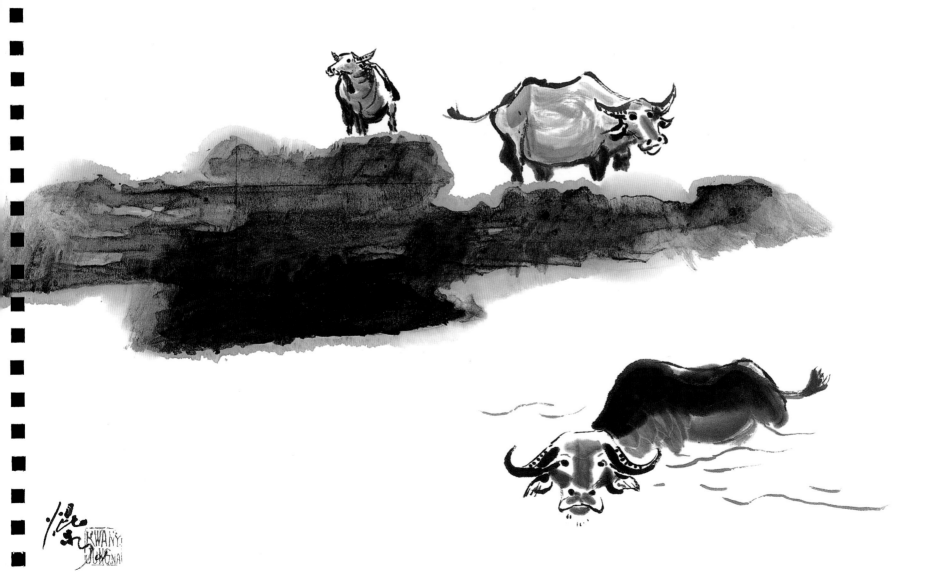

ORANGUTAN
Acrylic
19" x 13" (48cm x 33cm)

CROW AND BANANA TREE
Acrylic
26" x 17" (66cm x 43cm)

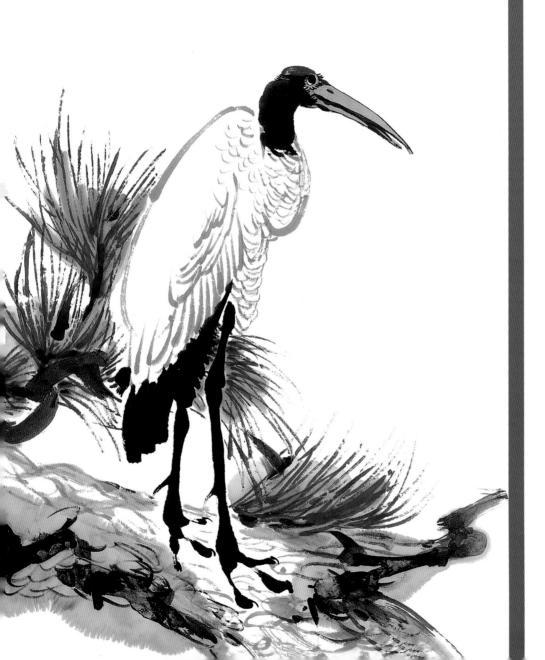

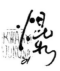

PINE TREE AND CRANE NO. 1
Acrylic
26" x 17" (66cm x 43cm)

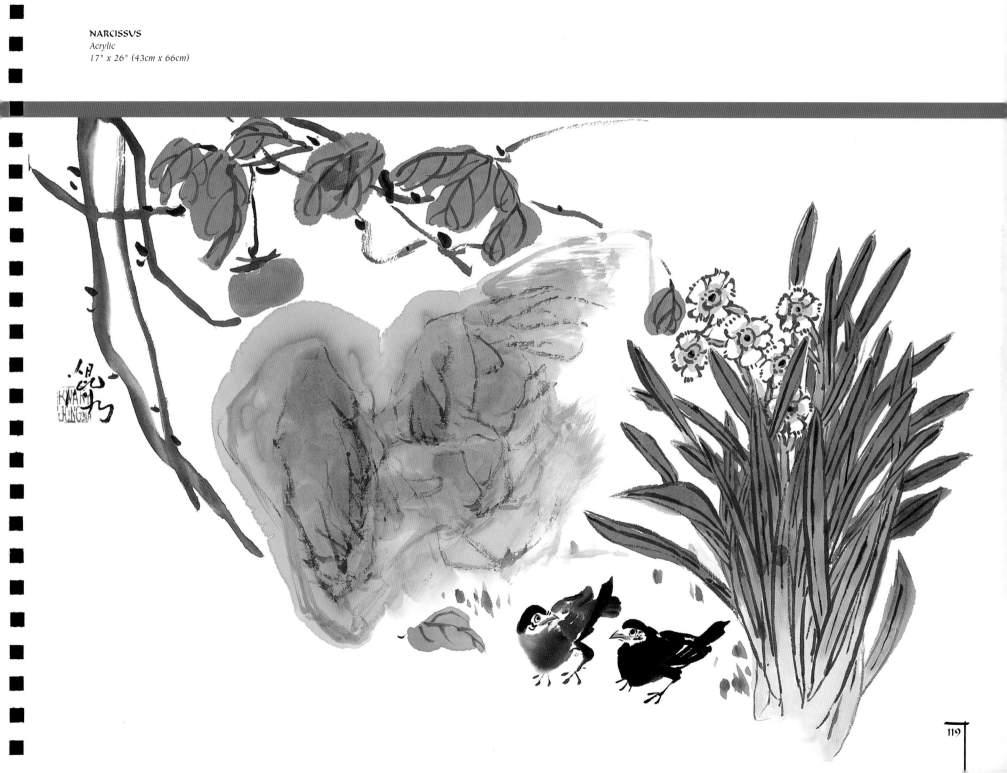

BUMBLE BEE AND MORNING GLORY
Acrylic
26" x 16" (66cm x 41cm)

HEN AND CHICKS
Acrylic
27" x 18" (69cm x 46cm)

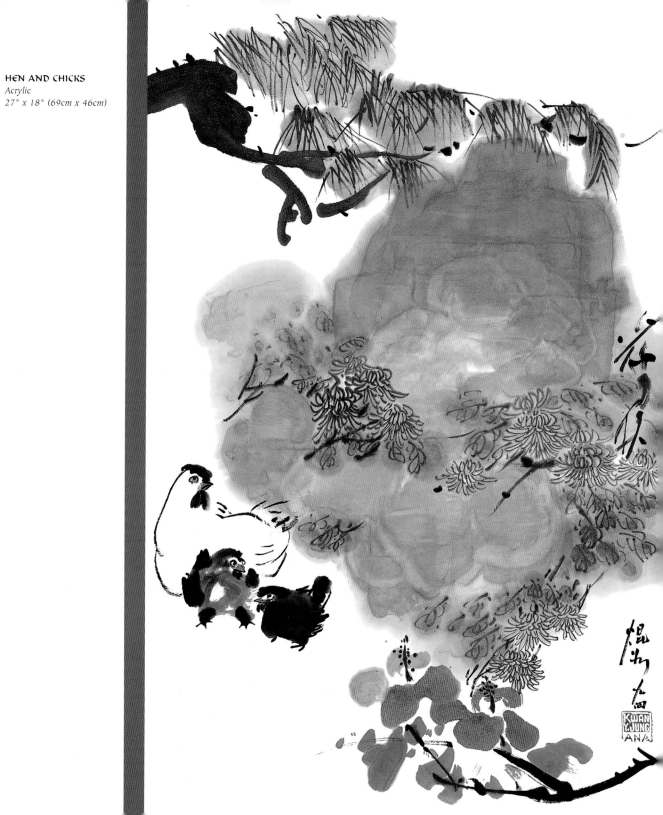

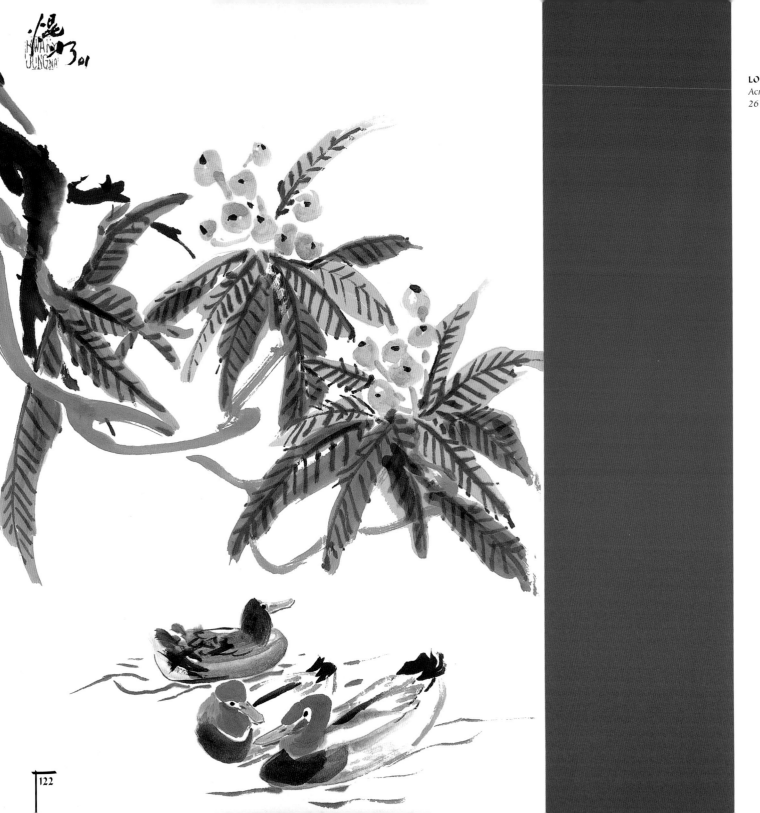

LOQUAT TREE AND MALLARD
Acrylic
26" x 17" (66cm x 43cm)

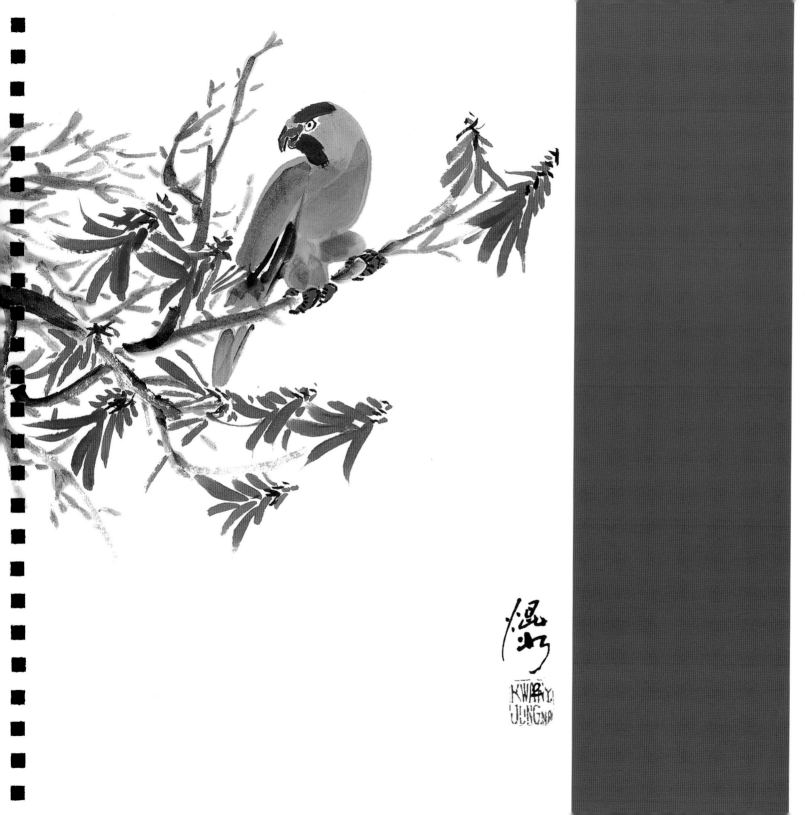

BLUE CROWNED LORY AND CORAL TREE
Acrylic
17" x 12" (43cm x 30cm)

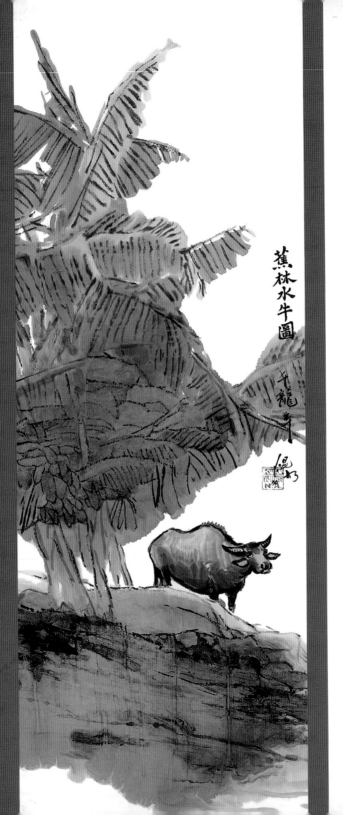

BANANA TREE AND THE
STANDING WATER BUFFALO
Acrylic
38" x 14" (97cm x 36cm)

PINE TREE AND CRANE NO. 2
Acrylic
38" x 14" (97cm x 36cm)

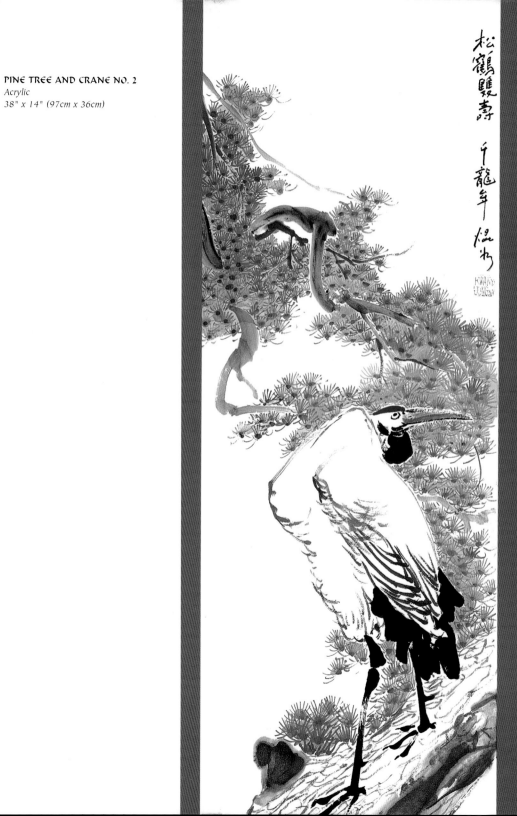

松鶴延壽 于龍年偶picture

INDEX

THE BEST PAINTING INSTRUCTION
COMES FROM NORTH LIGHT BOOKS!

These books and other fine North Light titles are available from your local art & craft retailer, book store, online supplier or by calling 1-800-448-0915.

Using a few brushes, some rice paper and a small number of inks and paints, you can explore new realms of watercolor art. Lian Quan Zhen provides step-by-step instructions that enable you to apply every brushstroke with strength and confidence. And you'll find inspiration in Zhen's own works, created with the best techniques from East and West.

ISBN 1-58180-000-2, hardcover, 144 pages, #31658-K

Cristina Acosta shows you how to re-connect with the imagination, creativity and energy of your childhood to create amazing works of art! She'll help you re-think color mixing and design, while developing your own personal style in acrylic or any other medium. Every lesson is designed to make your painting easier, more satisfying and, most importantly, more fun!

ISBN 1-58180-118-1, paperback, 112 pages, #31814-K

More than one thousand art-related definitions and descriptions are detailed here for your benefit. Including every term, technique and material used by the practicing artist, this unique reference is packed with photographs, paintings, mini-demos, black & white diagrams and drawings for comprehensive explanation. Special sidebars elaborate on specific entries providing a wealth of inter-related information in one convenient listing.

ISBN 1-58180-023-1, paperback, 512 pages, #31677-K

Claudia Nice introduces you to the joys of keeping a sketchbook journal, along with advice and encouragement for keeping your own. Exactly what goes in your journal is up to you. Sketch quickly or paint with care. Write about what you see. The choice is yours—and the memories you'll preserve will last a lifetime.

ISBN 1-58180-044-4, hardcover, 128 pages, #31912-K